LAS VEGAS
portrait of a city

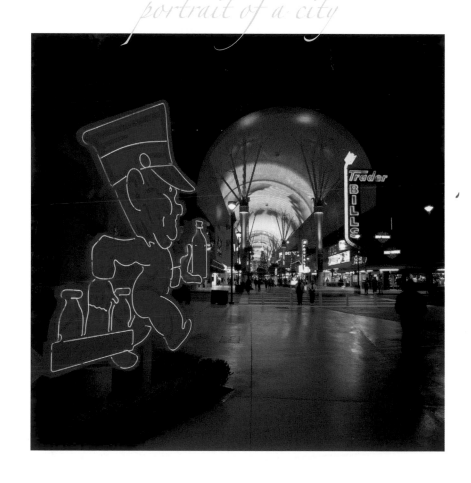

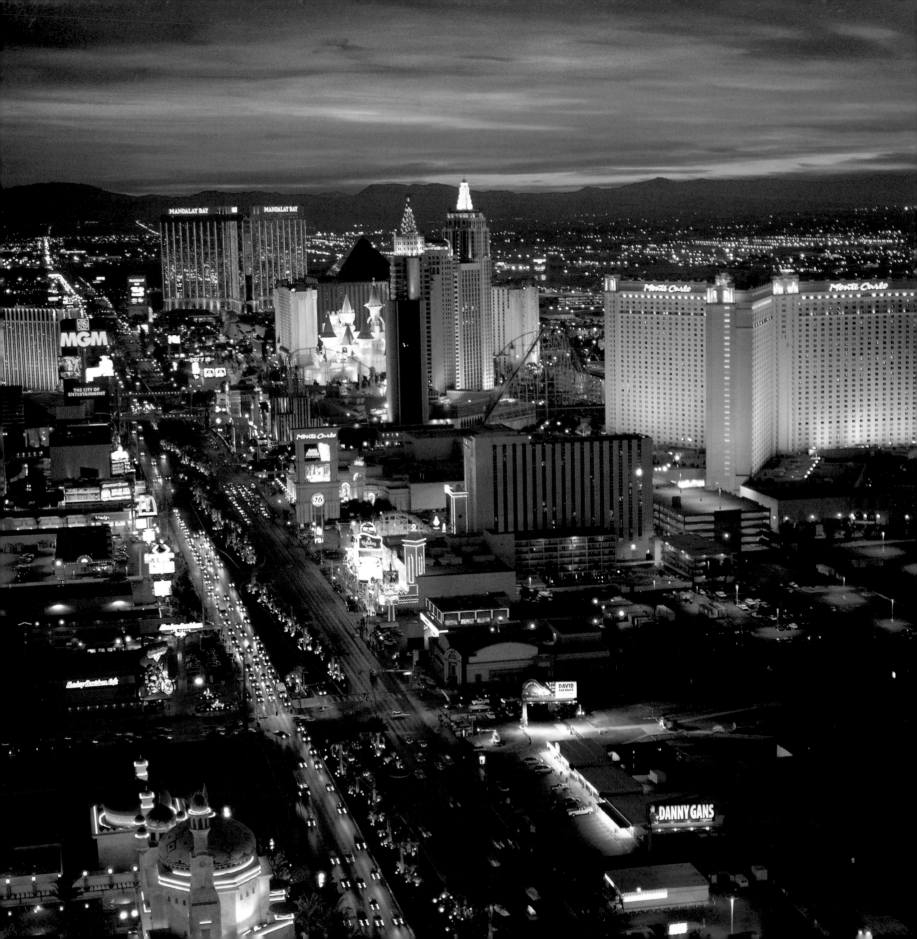

LAS VEGAS
portrait of a city

DEON AND TRISH REYNOLDS

GRAPHIC ARTS BOOKS

Captions and book compilation © MMVI by
Graphic Arts Books, an imprint of
Graphic Arts Center Publishing Company
P.O. Box 10306, Portland, Oregon 97296-0306
503/226-2402; www.gacpc.com

The five-dot logo is a registered trademark of
Graphic Arts Center Publishing Company.

International Standard Book Number: 978-1-55868-949-7

President: Charles M. Hopkins
Associate Publisher: Douglas A. Pfeiffer
Editorial Staff: Timothy W. Frew, Kathy Howard, Jean Bond-Slaughter
Production Staff: Richard L. Owsiany, Heather Doornink
Cover Design: Elizabeth Watson
Interior Design and Captions: Jean Andrews

Printed in China

FRONT COVER: ◖ The *Eiffel Tower* rises above "the Strip."
BACK COVER: ◖ *Splash* lights the entrance to the Riviera Casino.
HALF-TITLE PAGE: ◖ *Andy Anderson,* created in 1956 as the mascot
for the Anderson Dairy, became part of the Neon Museum in July of 1997.
FRONTISPIECE: ◖ The Las Vegas Strip presents a bright and colorful nighttime cityscape.
▶ The million-dollar *Volcano Fountain* at the Mirage Hotel puts on an exuberant
water and fire-spitting show. After dark, water and fire—jointly and separately—
burst from the top of the molehill, making it appear as if a volcano
were erupting. Red spotlights illuminate the waterfall, and
loudspeakers thunder in sync with the "eruption."

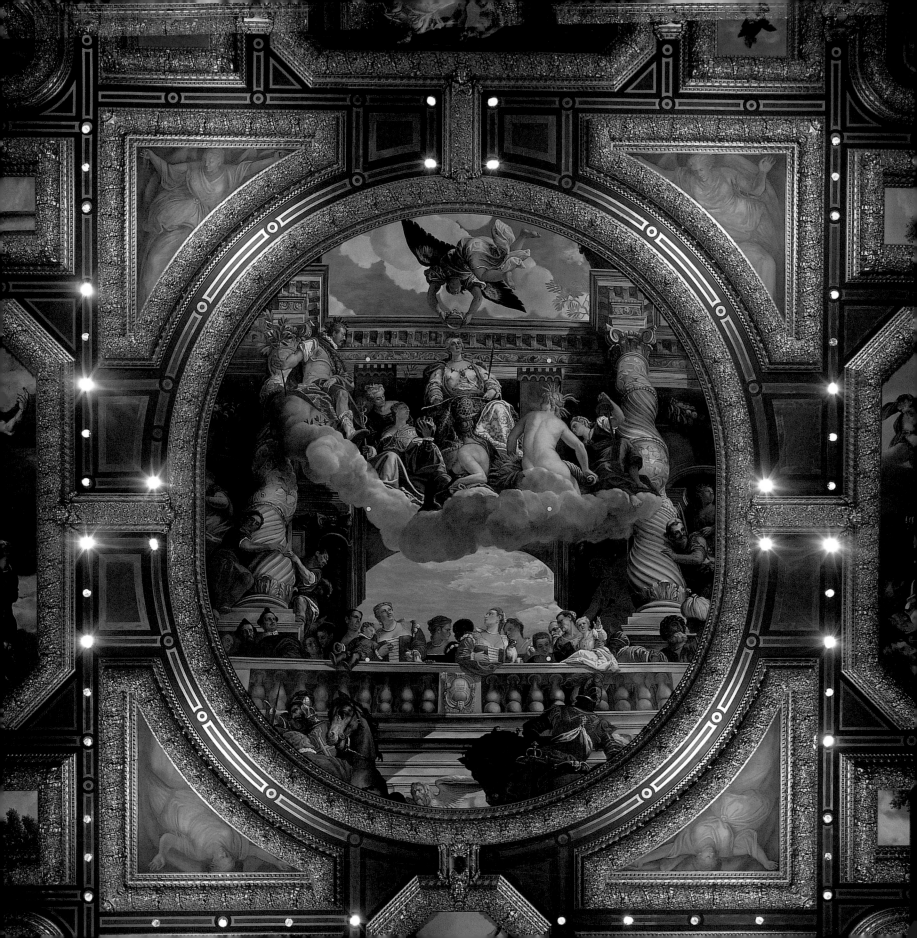

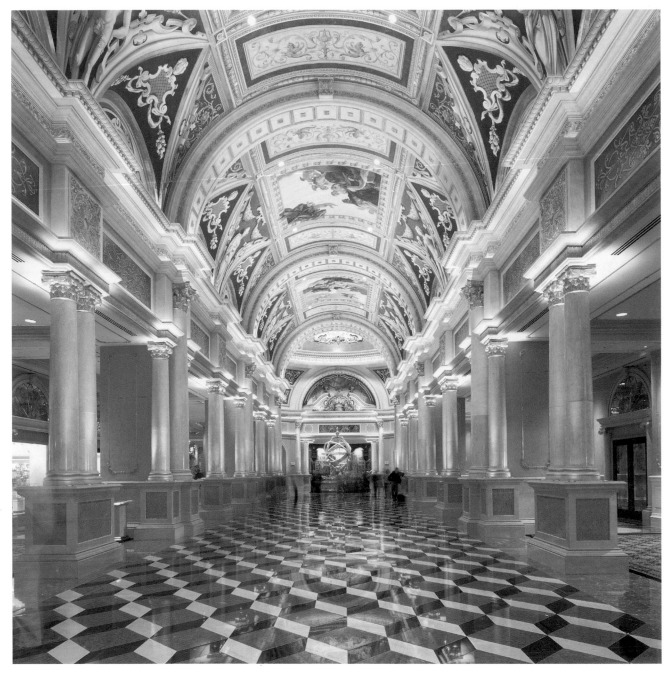

◄ The decorated ceiling of the Venetian
Las Vegas Hotel and Casino hints at the opulence of Renaissance
Venice. Bridges, canals, and stone walkways complete the ambience.
▲ The inside of the Venetian is lavishly detailed with marble floors,
colorful hand-painted frescoes, and plush furnishings.

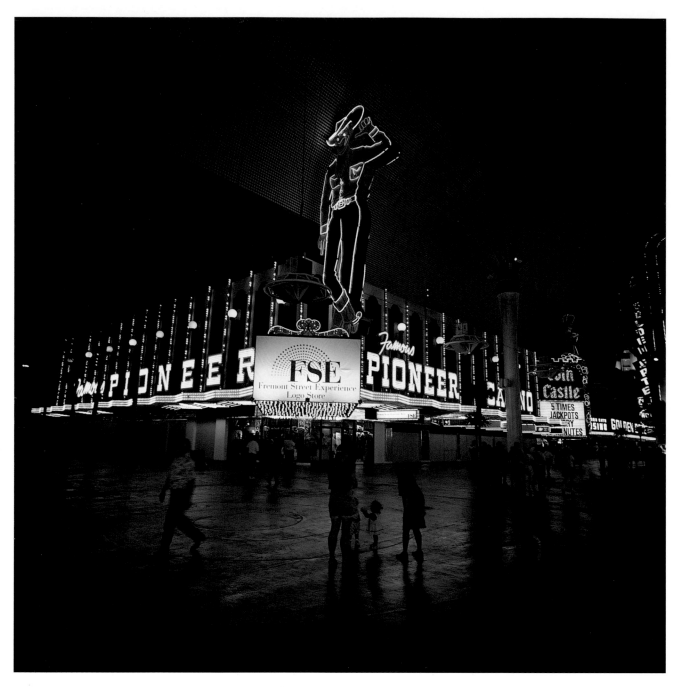

▲ *Vegas Vic,* the product of a post–World War II
booster campaign, reigns atop the Famous Pioneer Casino.
Though the Pioneer has not been a casino since the 1990s and is now a
gift shop, *Vegas Vic* still reminds one of the old Vegas days.

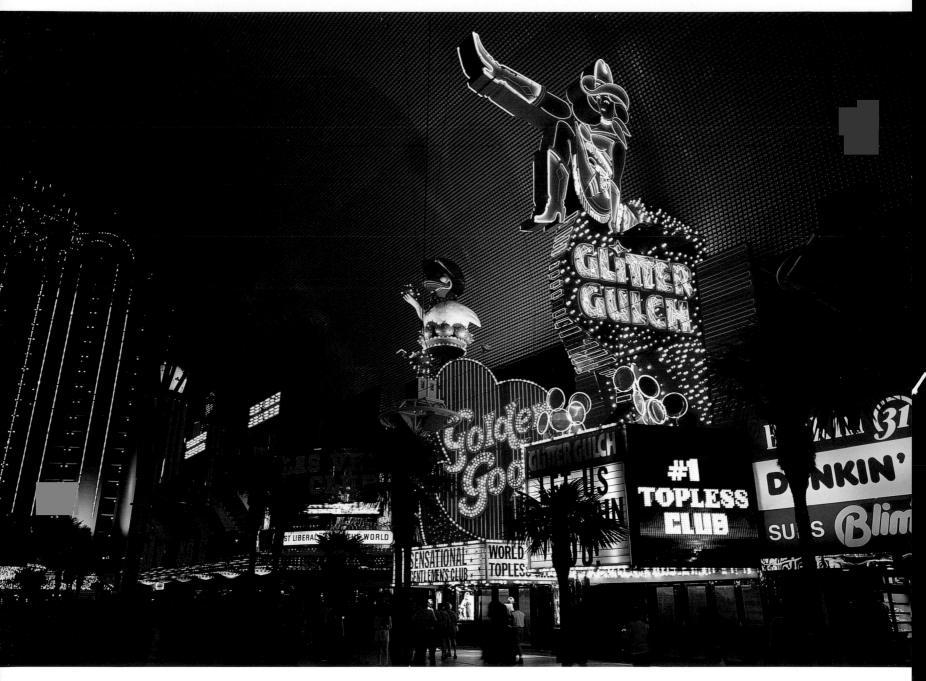

▲ Known as *Sassy Sally* prior to
her "marriage" to *Vegas Vic*, the neon
cowgirl is now known as *Vegas Vickie*. She is
situated in Fremont Street's Glitter Gulch
just half a block from *Vegas Vic*.

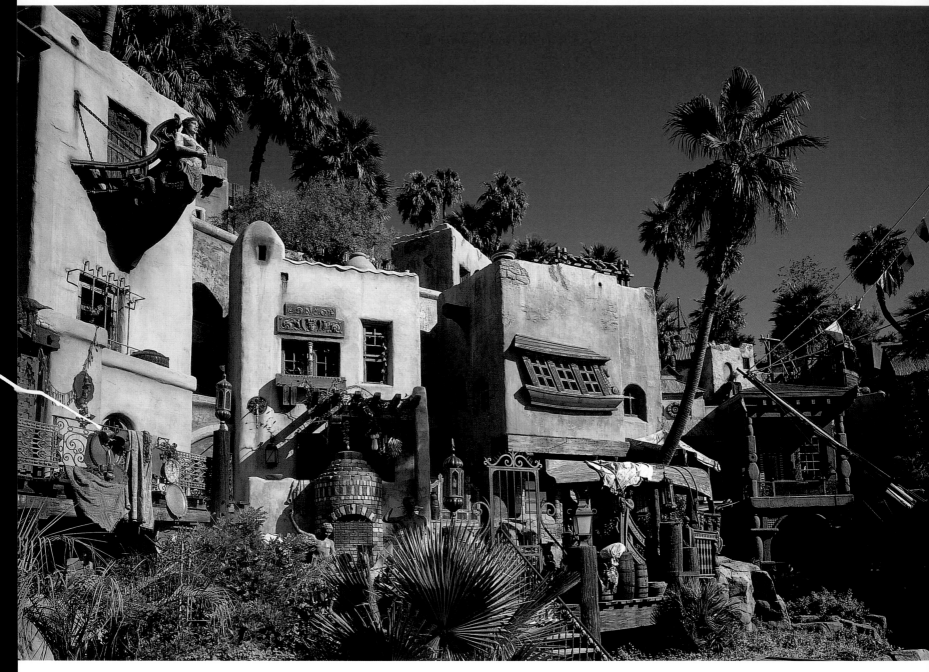

▲ Treasure Island Hotel and Casino at
the Mirage is a romantic adventure getaway.
► Among other entertainment, Treasure Island features
nightly live performances of the beautiful Sirens of Treasure Island
in a battle of the sexes with a band of pirates at Sirens' Cove.
►► Belying Nevada's arid climate, Treasure Island
flaunts a verdant tropical setting.

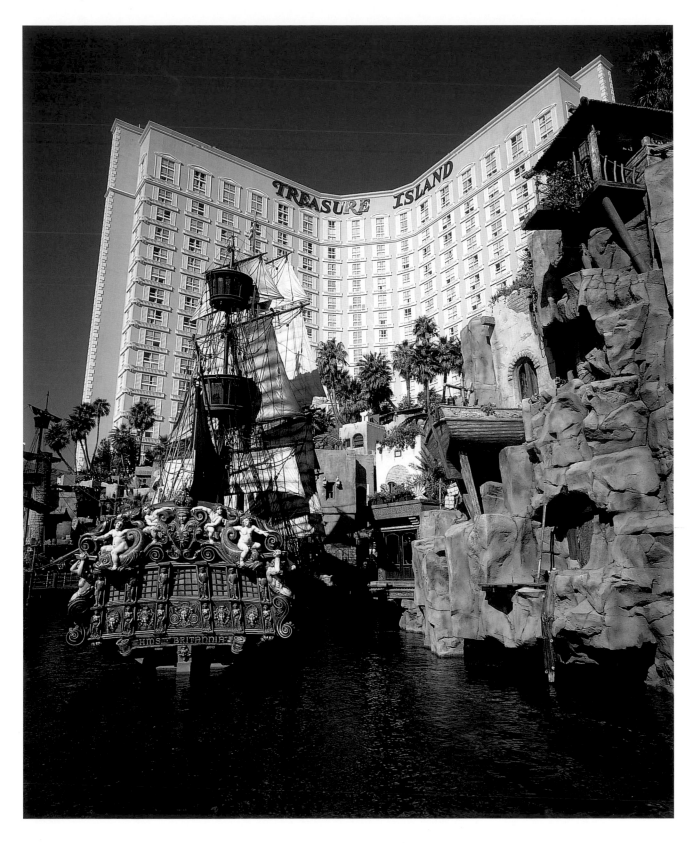

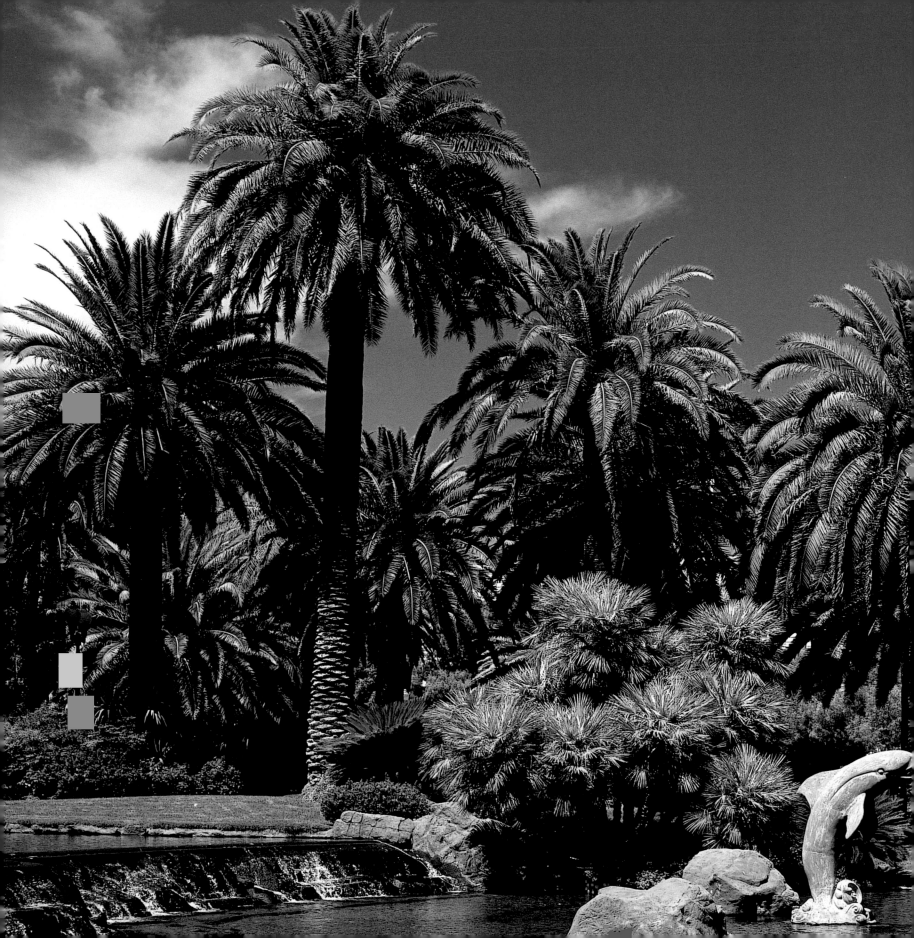

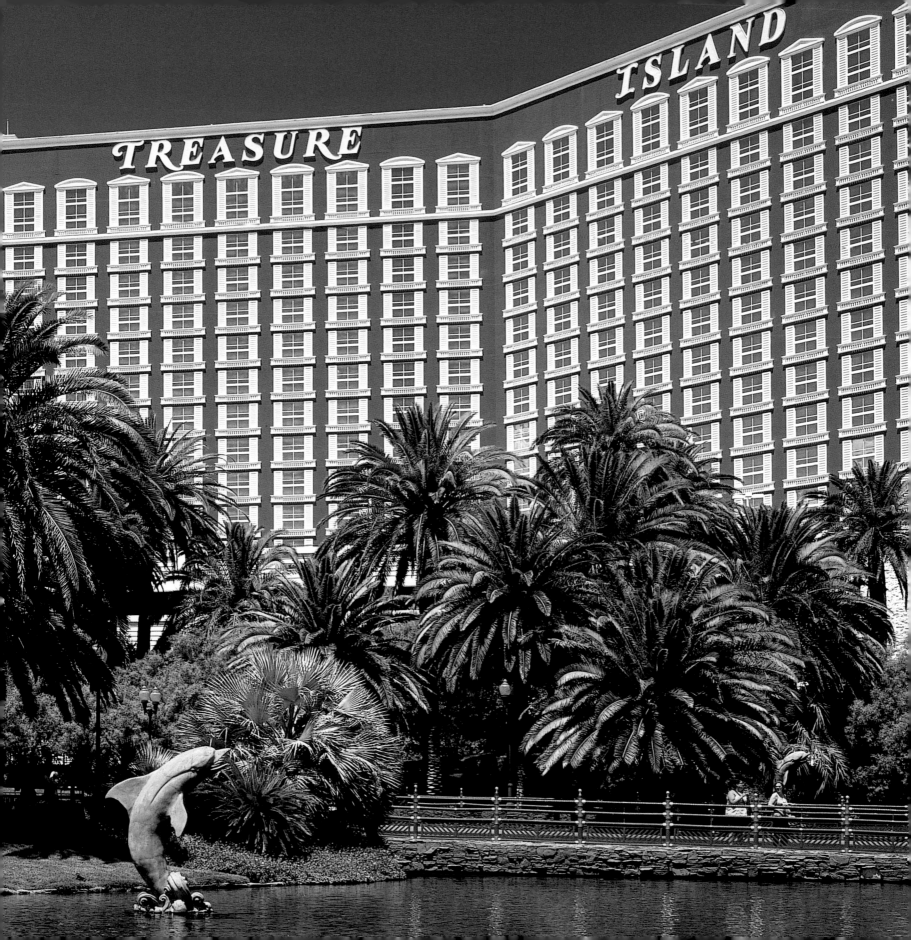

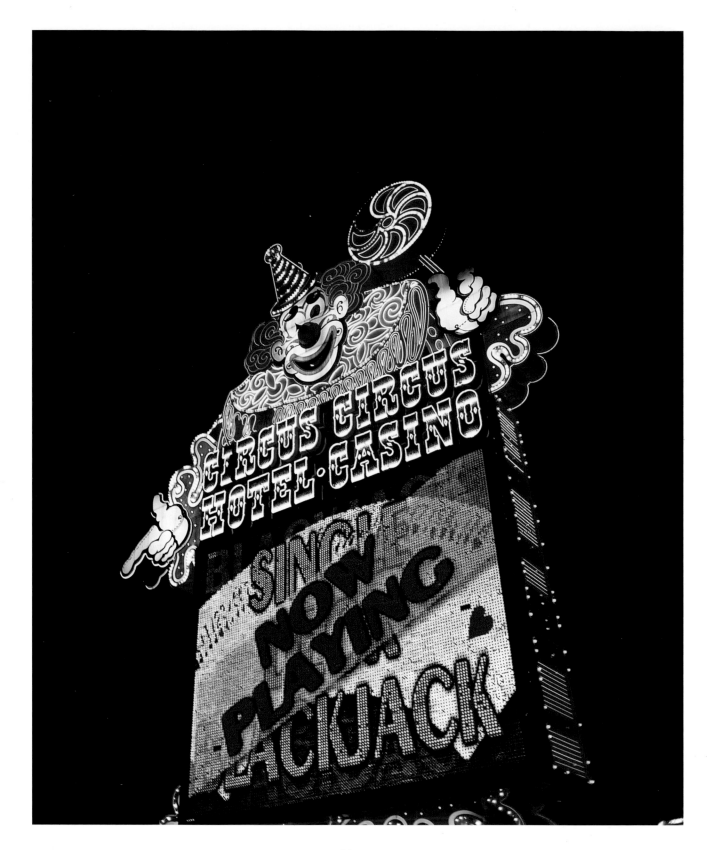

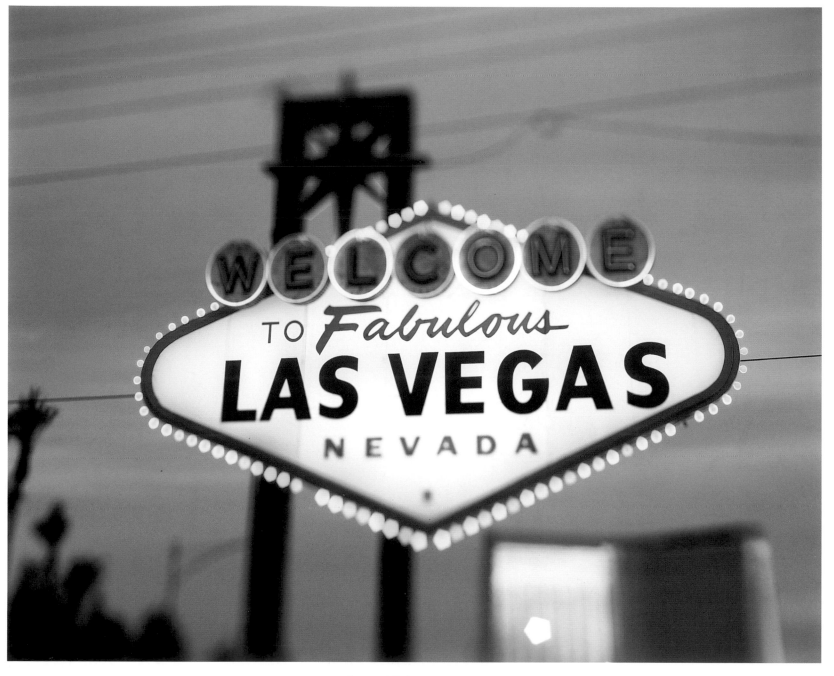

◄ The world's largest permanent
circus and American's largest indoor theme park
team up with the world-famous Carnival Midway to provide
fun for all ages at Circus Circus Las Vegas Hotel Resort and Casino.
▲ Backdropped by palm trees, the *Welcome to Fabulous Las Vegas Nevada*
neon sign greets travelers as they enter the Las Vegas experience.

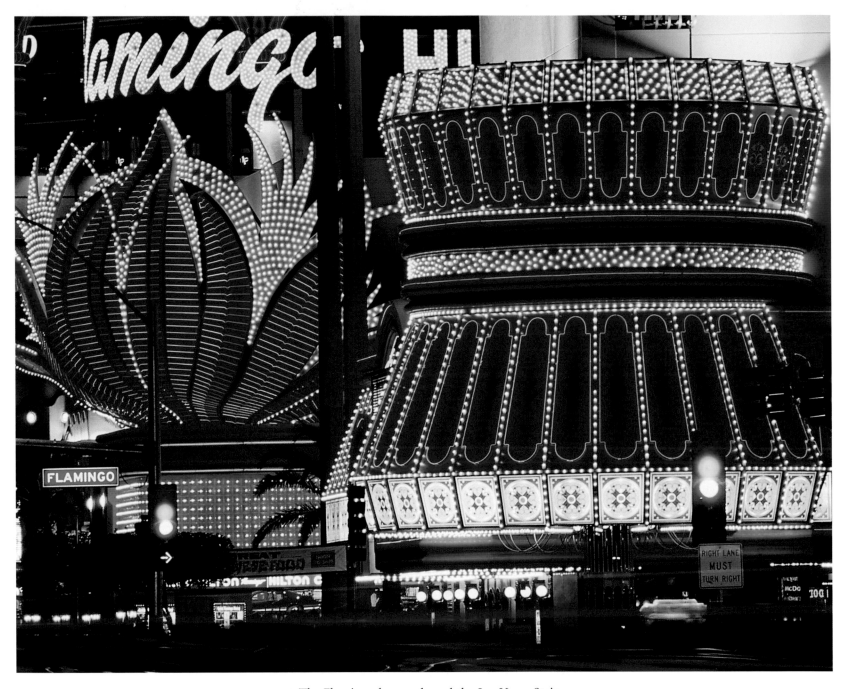

▲ The Flamingo has anchored the Las Vegas Strip
since 1946. A self-contained resort and casino, the Flamingo is a
study in pink, from the neon sign to the lobby carpeting to the hotel room vases.
▶ The Bellagio's world-famous fountains combine with opera, classical, and
whimsical music to create a breathtaking union of water, music, and light.

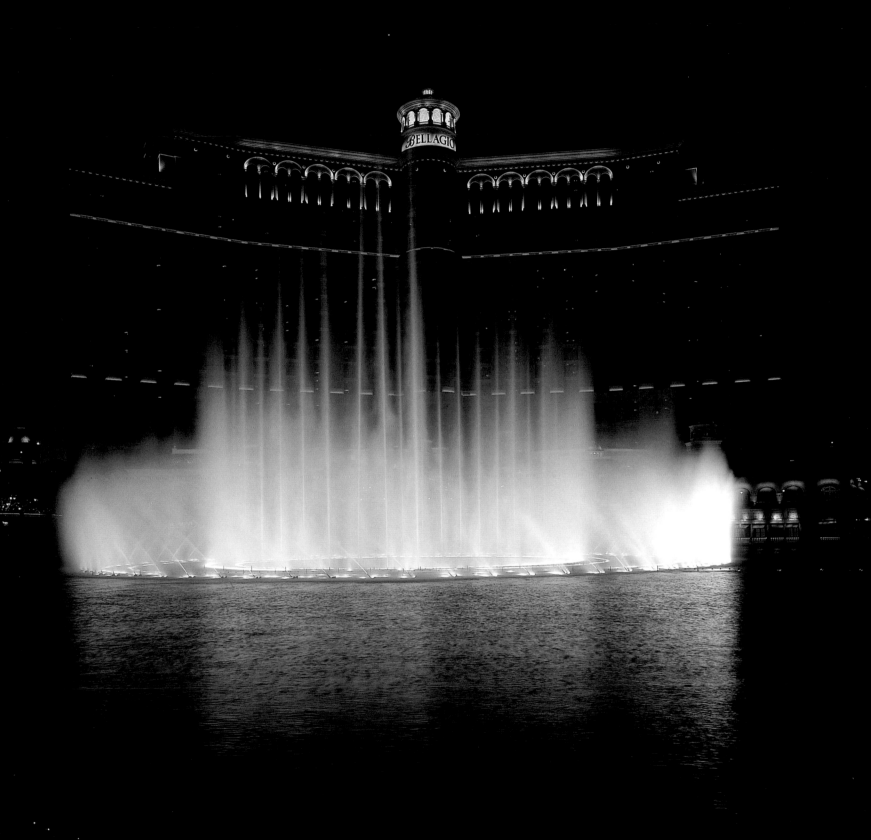

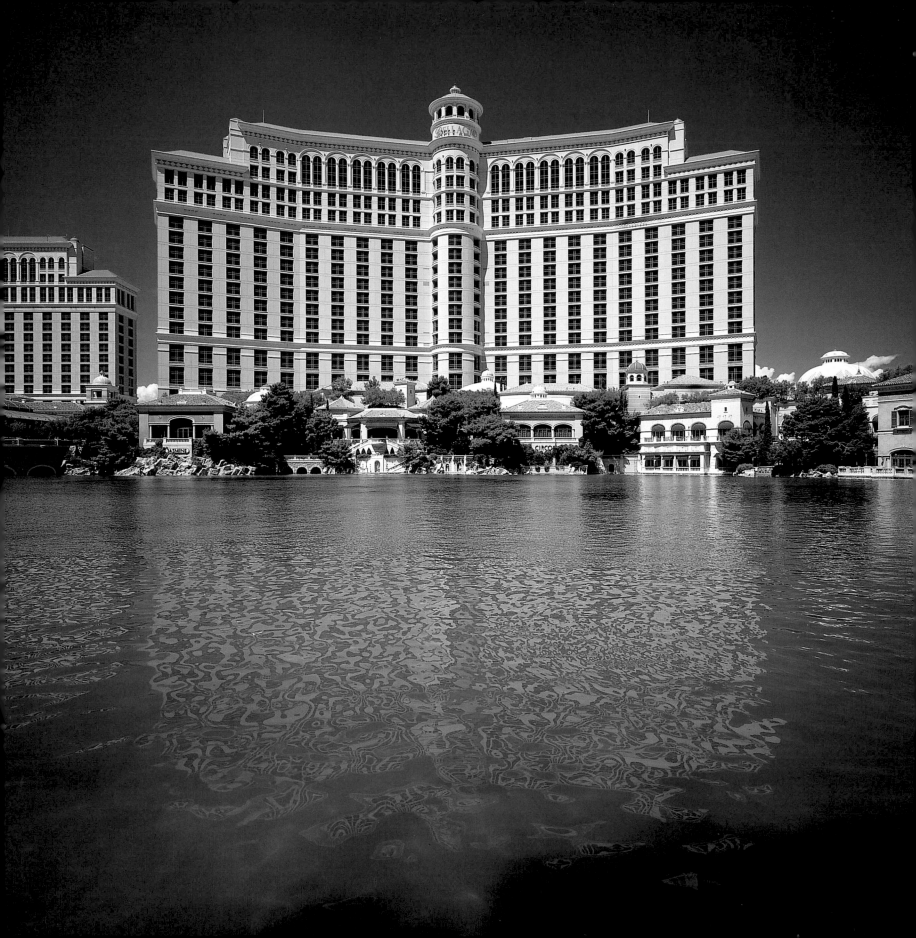

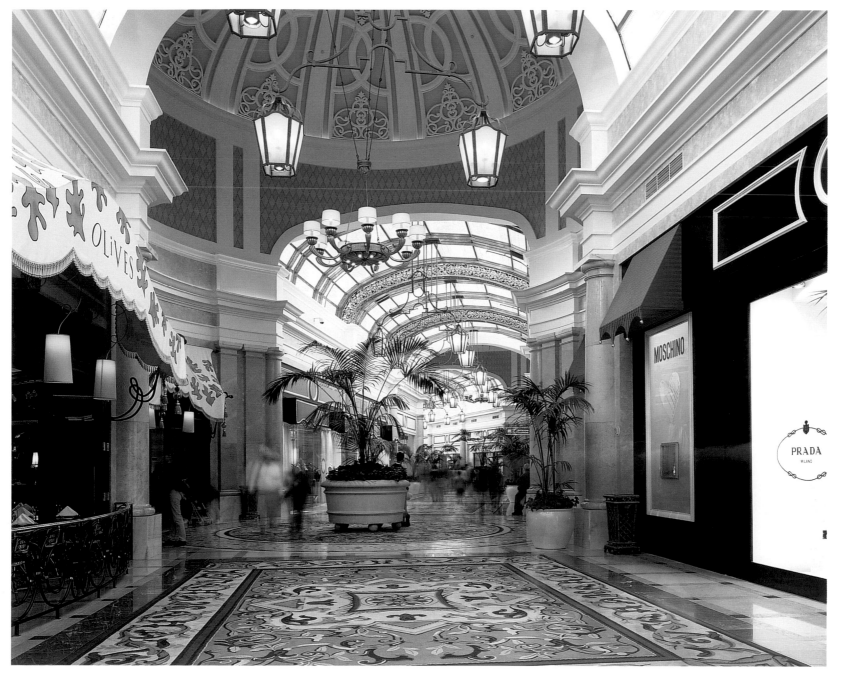

◄ The Bellagio's pool and fountains
create an intimate backdrop for romantic trysts.
▲ Via Bellagio, the shopping arcade at the Bellagio hotel-casino, is
only part of the Bellagio experience; in addition are pools, a spa and salon,
golf, botanical gardens, a world-class gallery of art—and, of course, table games.
►► The ceiling of the Bellagio is emblazoned with 2,000 handblown glass flowers—
the *Fiori di Como,* created by world-renowned artist Dale Chihuly.

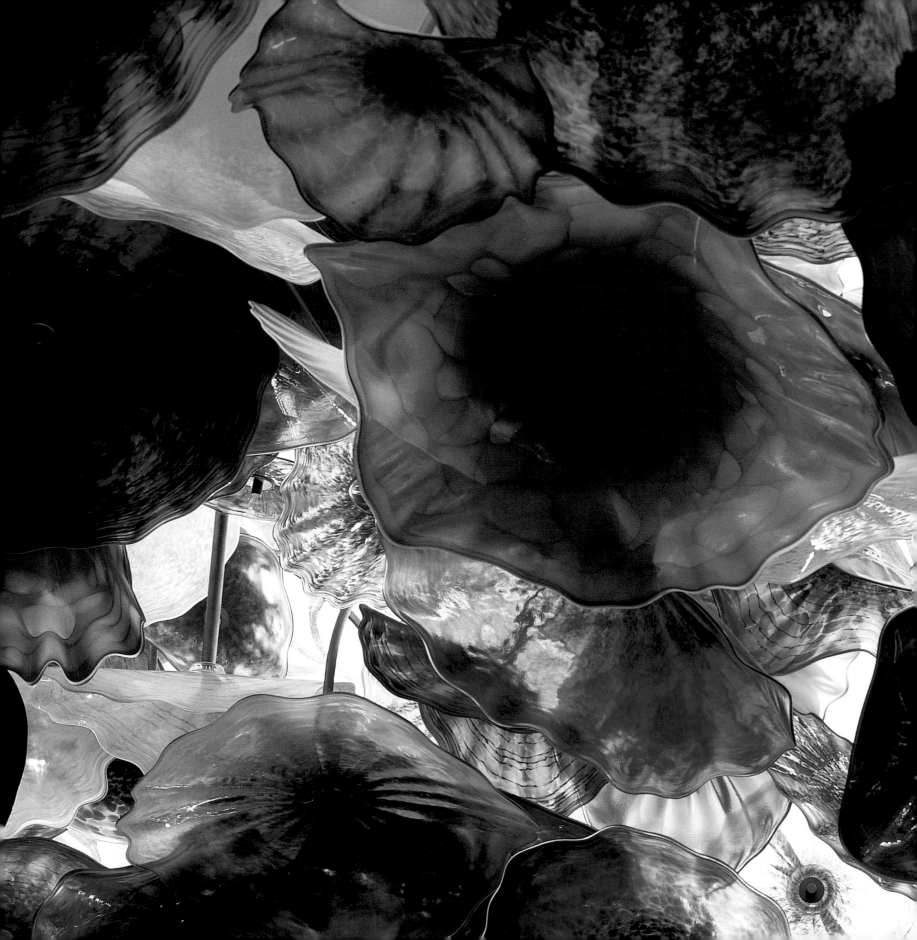

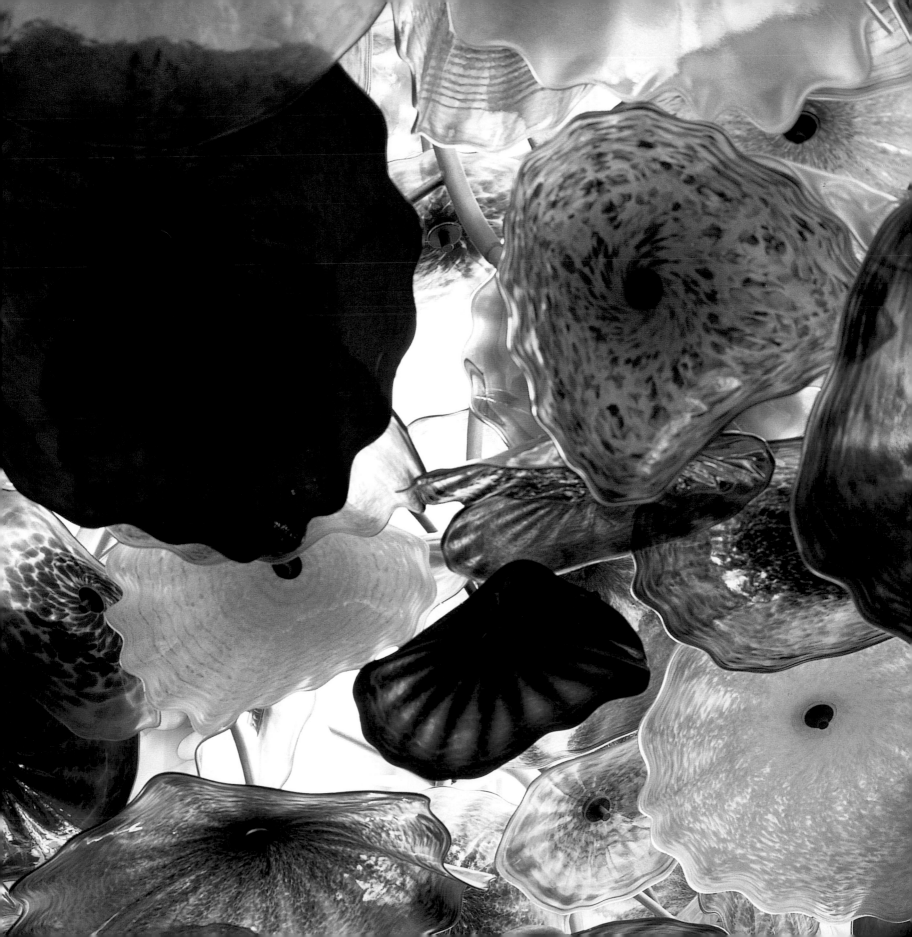

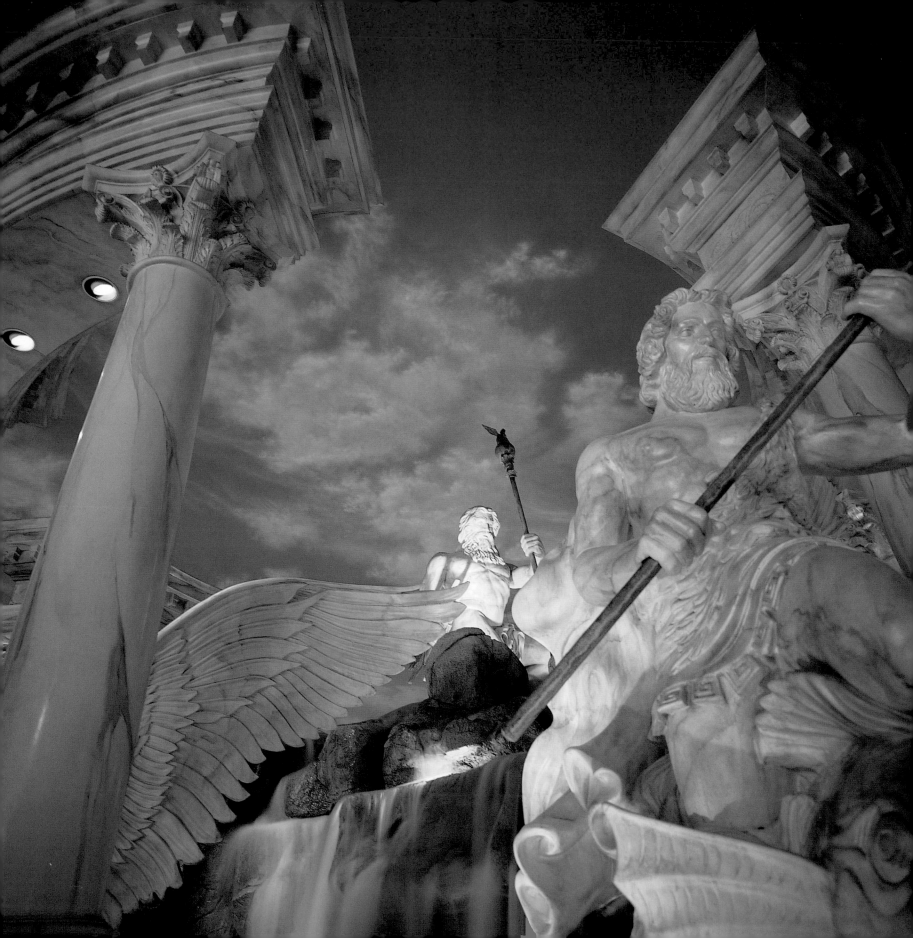

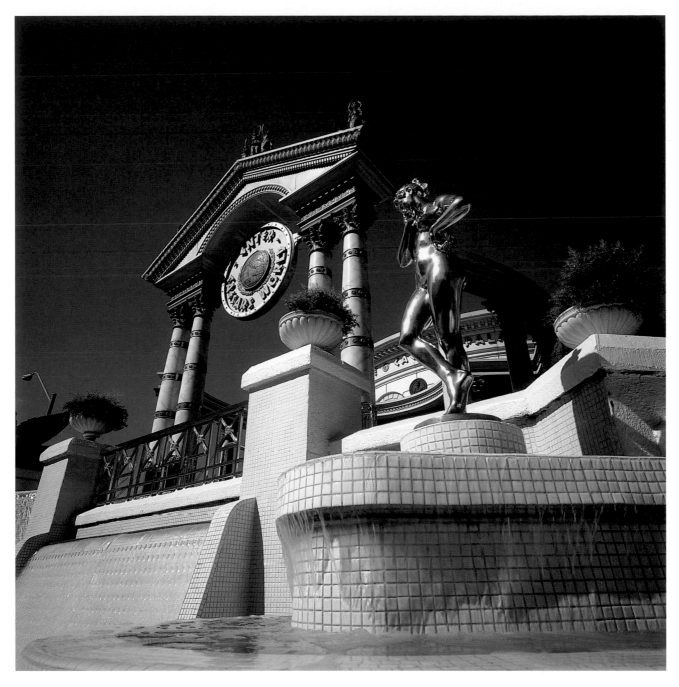

◄ Simulating the streets of ancient Rome,
the more than 160 stores embraced by the Forum
Shops at Caesars Palace create a unique retail attraction.
▲ Statues and intricate decorations are a
hallmark of Caesars Palace.

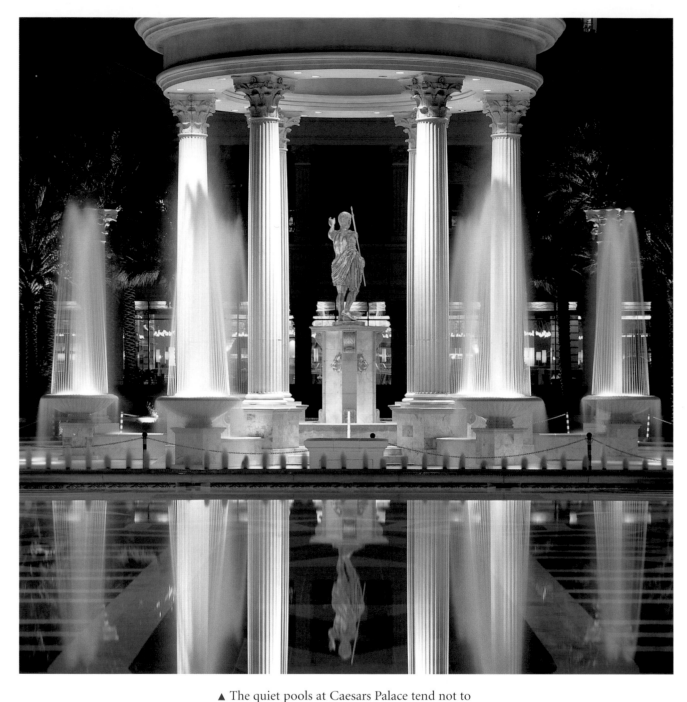

▲ The quiet pools at Caesars Palace tend not to
attract the crowds of kids found at other pools in Vegas;
there are no slides or waves. But adults are certainly attracted
by its peaceful atmosphere and submerged sunbathing platforms.
► Representing Caesars Palace is a statue of *Augustus of Prima Porta*.
Grand-nephew of Julius Caesar, Augustus ruled from 27 B.C.
to A.D. 14. He is considered the first emperor of Rome.

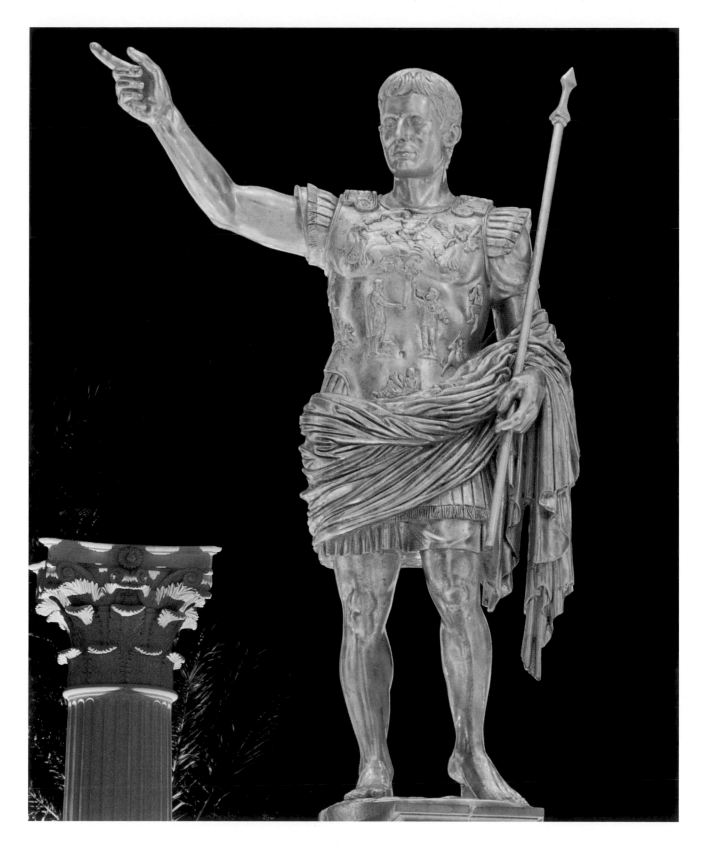

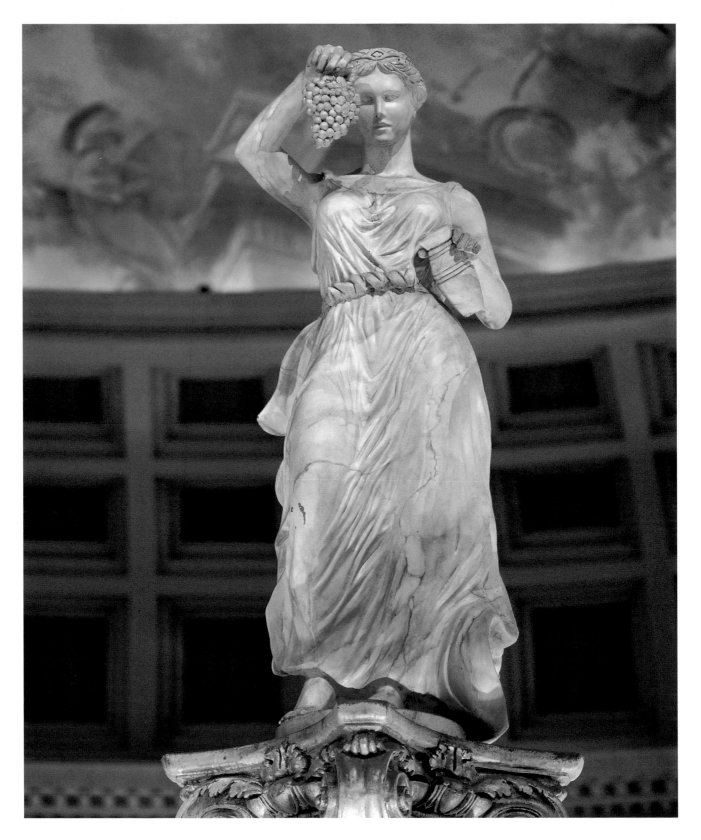

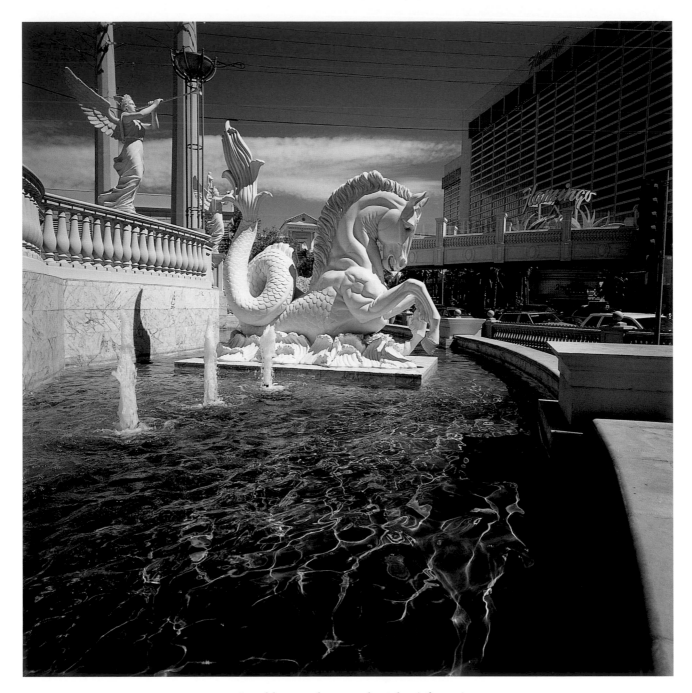

◄ A goddess watches over the *Atlantis* fountain
in front of the Forum Shops at Caesars Palace.
▲ Statuary is an integral part of the numerous
fountains surrounding Caesars Palace.

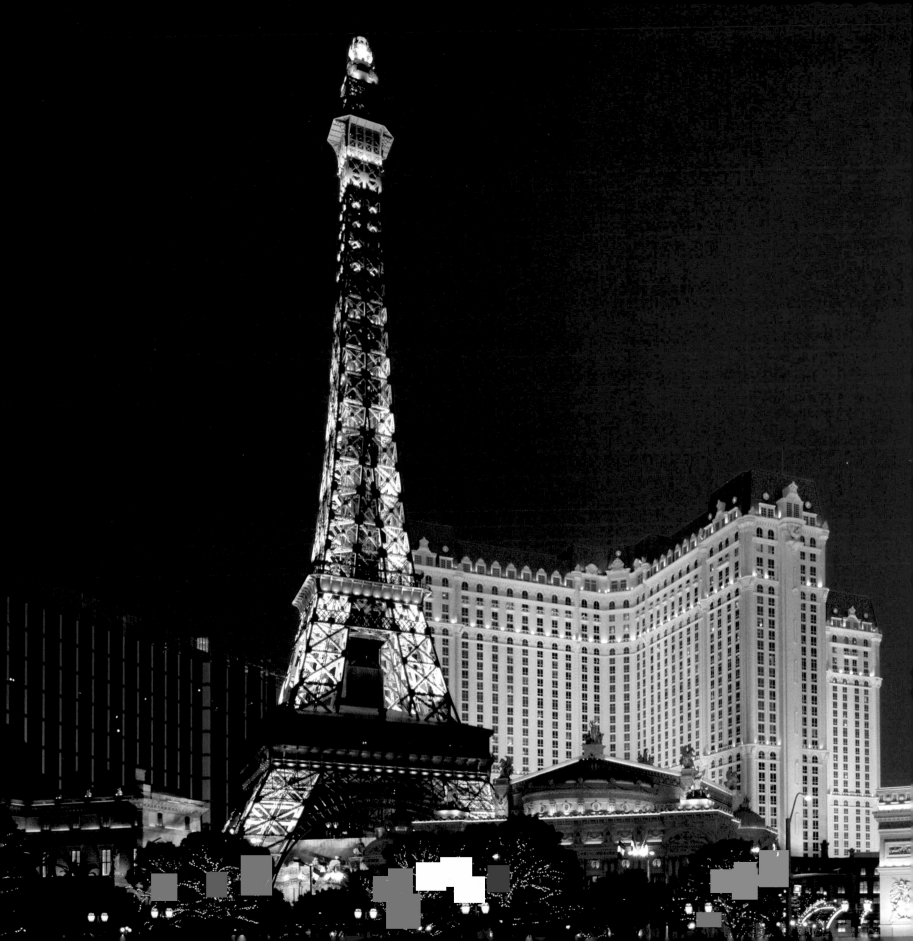

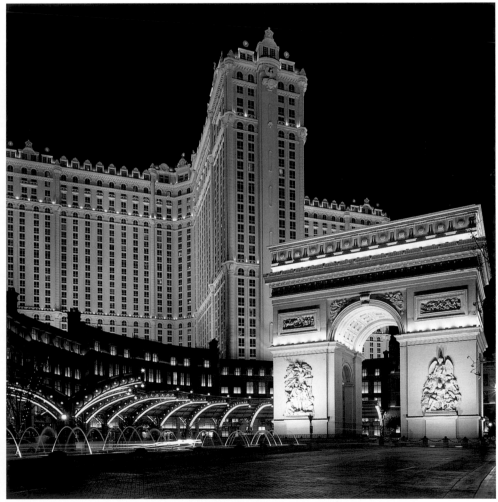

◄ Re-created meticulously at
one-half scale, the *Eiffel Tower* at Paris
Las Vegas reaches 460 feet into the sky. Three of the
four legs of the tower rise through the roof of the casino.
▲ The *Arc de Triomphe* at Paris Las Vegas is a two-thirds replica of
the original monument in Paris, France, honoring the soldiers
who fought for Napoleon in the 1805 Battle of Austerlitz.

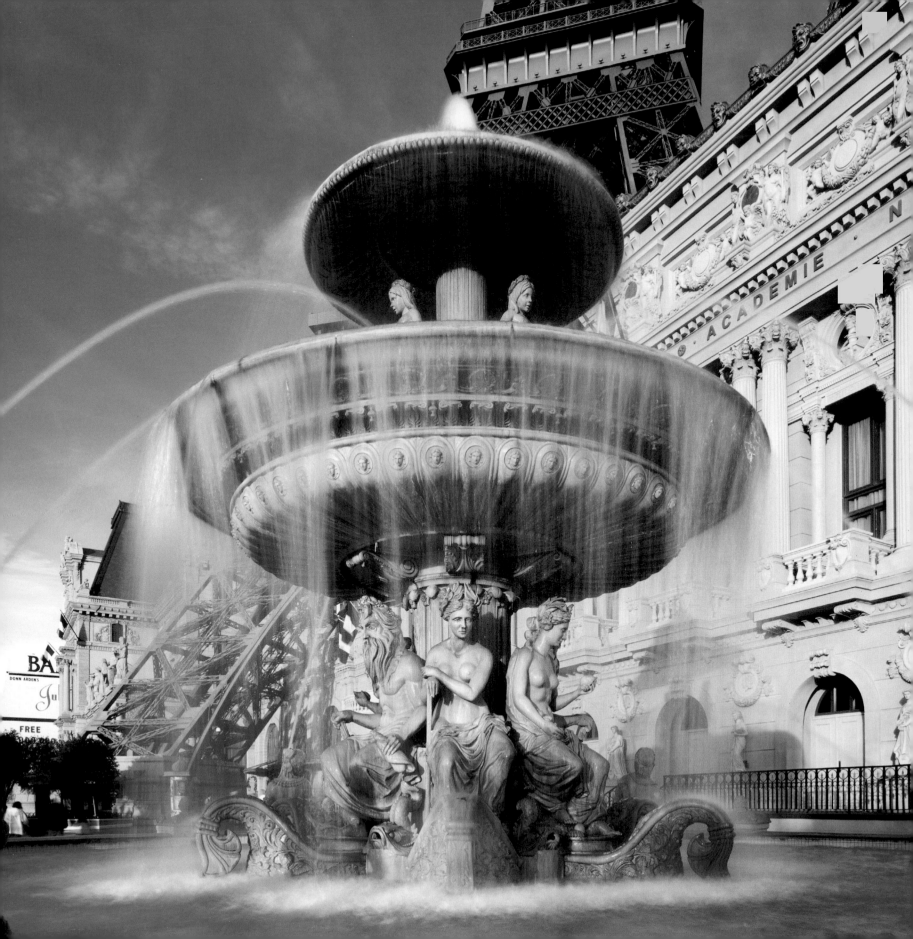

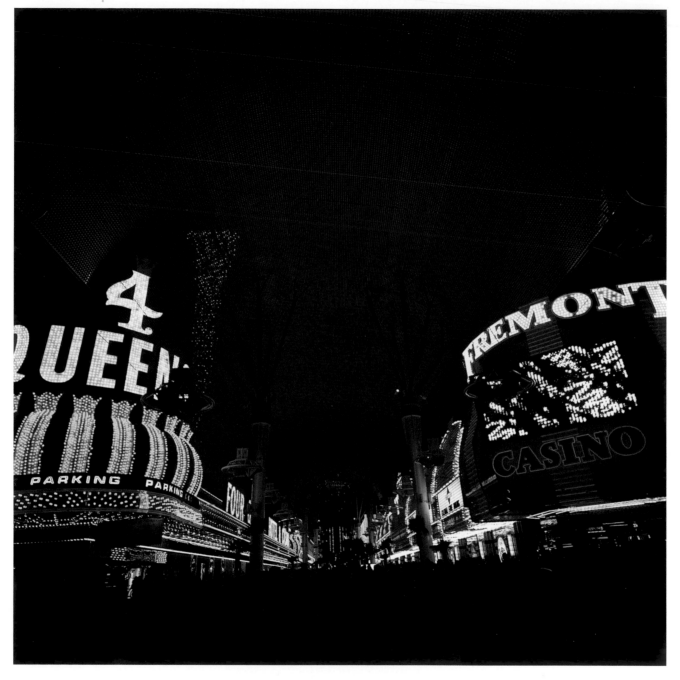

◄ Situated near the *Eiffel Tower* and
the Paris Resort Hotel and Casino, the *Concord*
fountain adds whimsy to the historical reproductions.
▲ The neon lights of Fremont Street show how
the street got its moniker—Glitter Gulch.

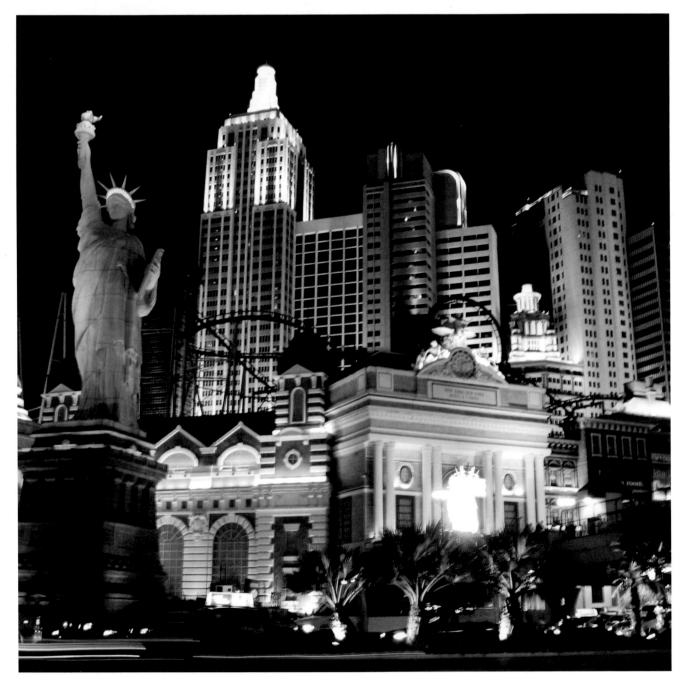

▲ New York, New York, seems
a bit out of place in Las Vegas, Nevada,
but the hotel and casino combine some of the most
famous sites of the Big Apple with the panache of Las Vegas.
► Among the spectacles in New York, New York, is the *Statue of Liberty*,
a one-third-scale re-creation that reaches about fifty feet high.

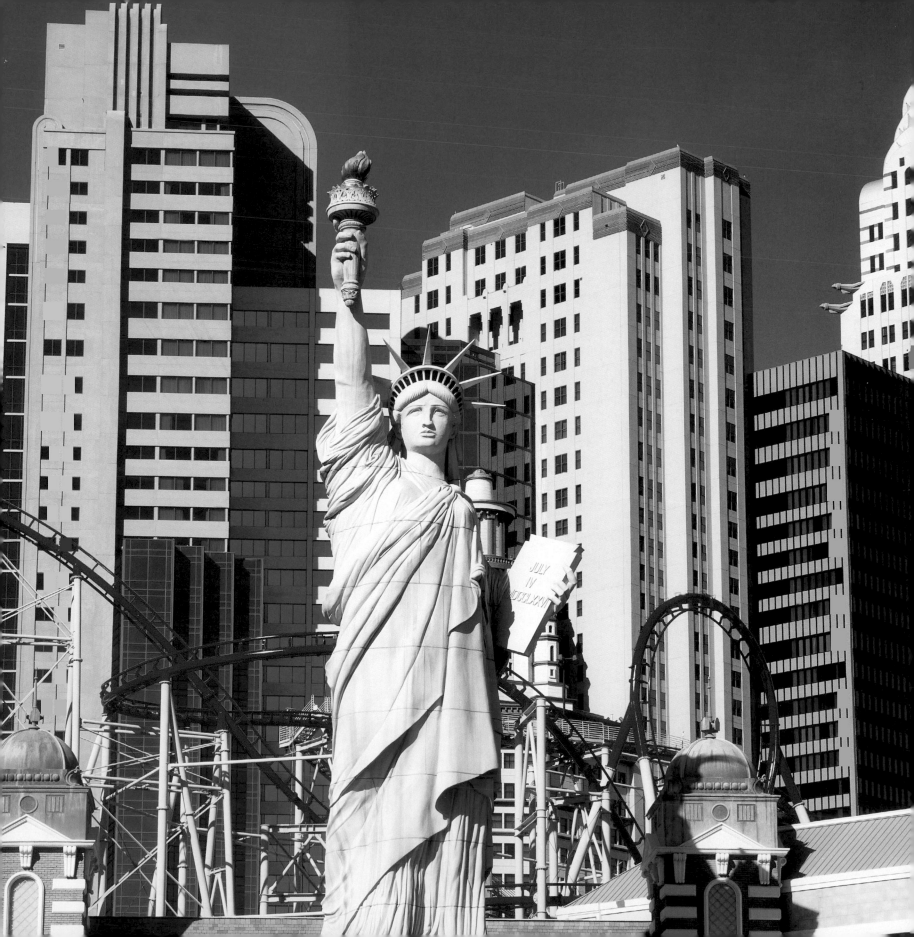

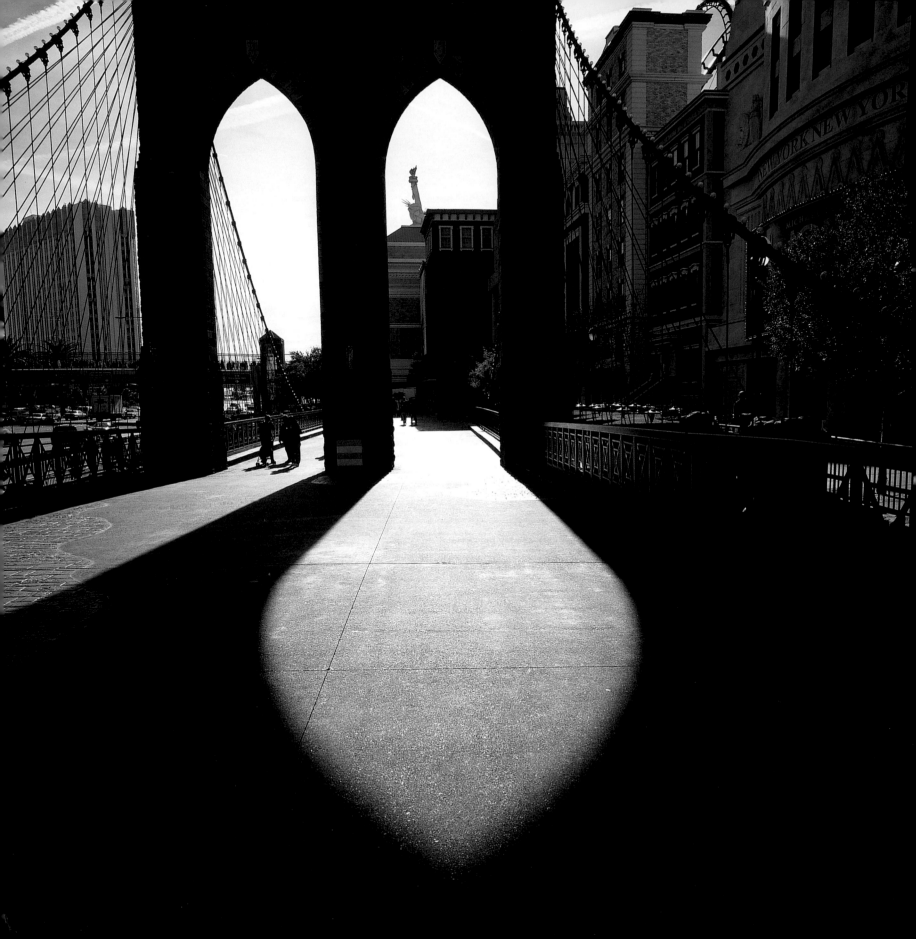

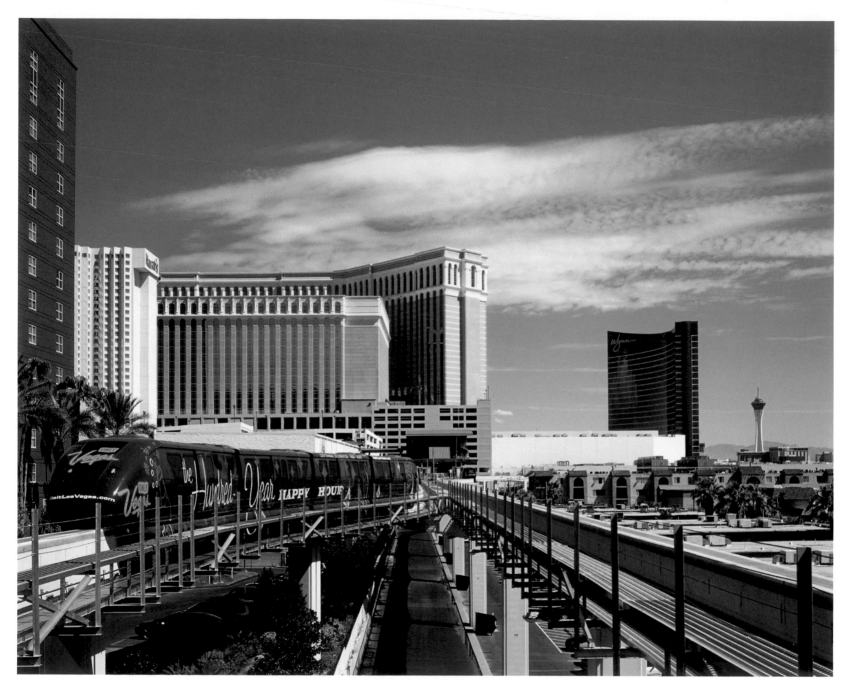

◄ One-fifth the size of the original—just 300 feet across—
the *Brooklyn Bridge, Las Vegas,* is crossed by some fifteen million people
each year, while only 940,000 pedestrians cross the original bridge in Manhattan.
▲ Traveling at speeds of up to fifty miles per hour, the Las Vegas Monorail
generally runs about twenty feet above city streets, though
it rises as high as seventy feet at one point.

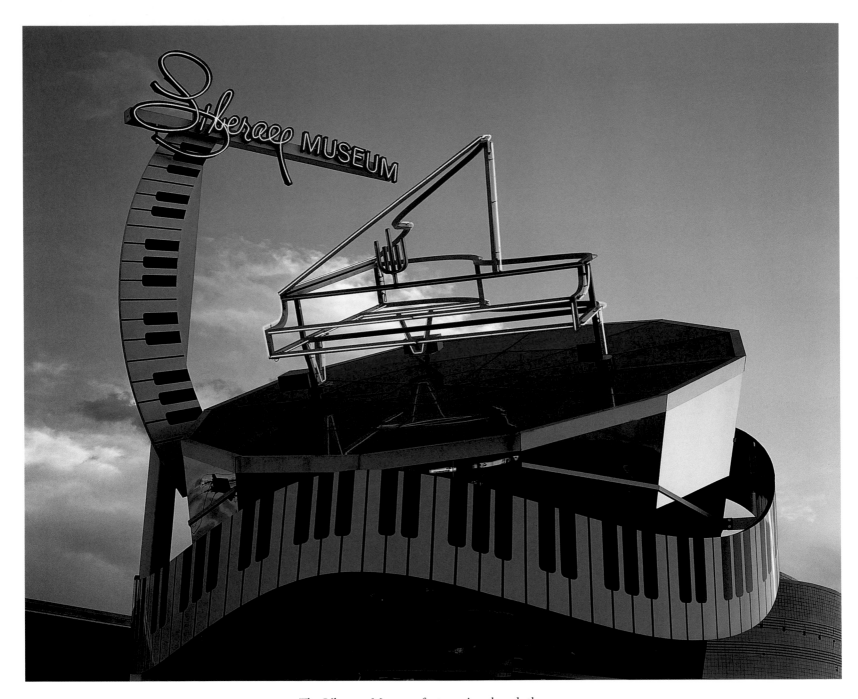

▲ The Liberace Museum features jewelry, clothes, cars,
antiques, and pianos once owned by the flamboyant entertainer.
► "Conceive of a space that is filled with moving," Gertrude Stein
wrote about America. Her vision describes neon Nevada.

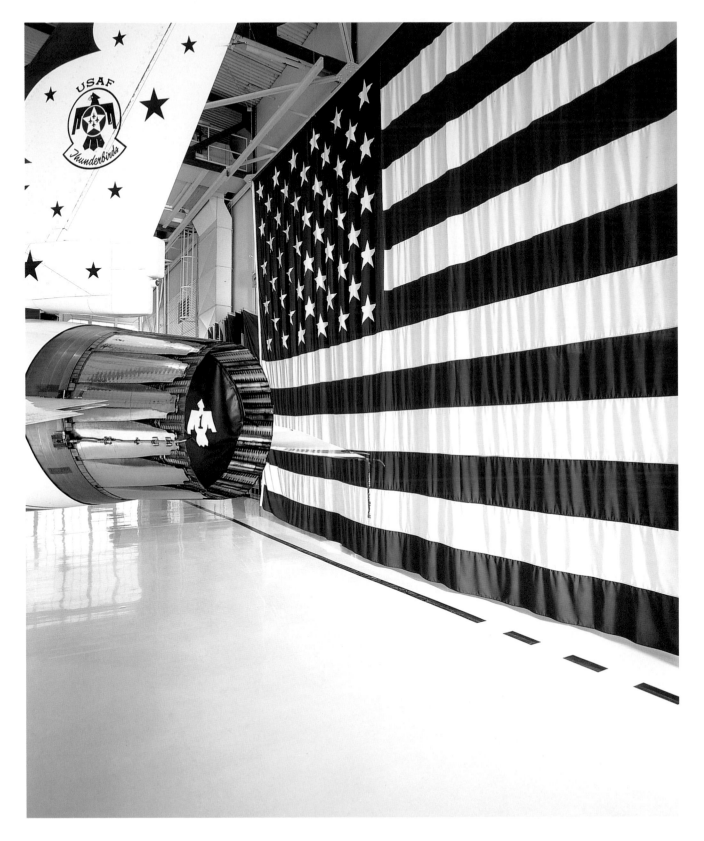

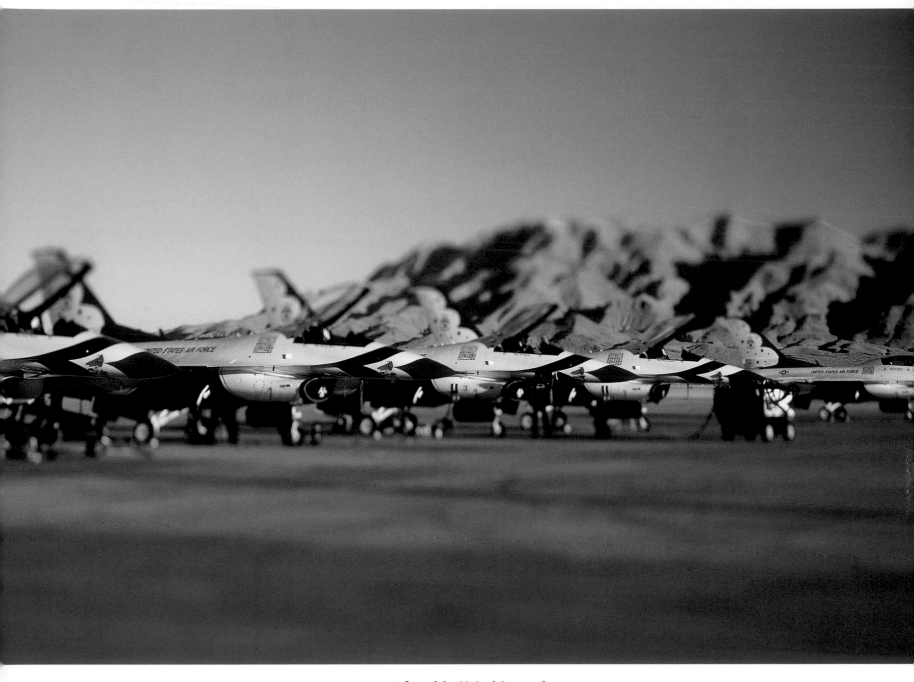

◄ A flag of the United States of
America covers a wall at Nellis Air Force Base,
home of the United States Air Force Air Demonstration
Squadron, better known simply as the Thunderbirds.
▲ F-16s wait to fly at Nellis. The Thunderbirds have
been based at Nellis for more than fifty years.

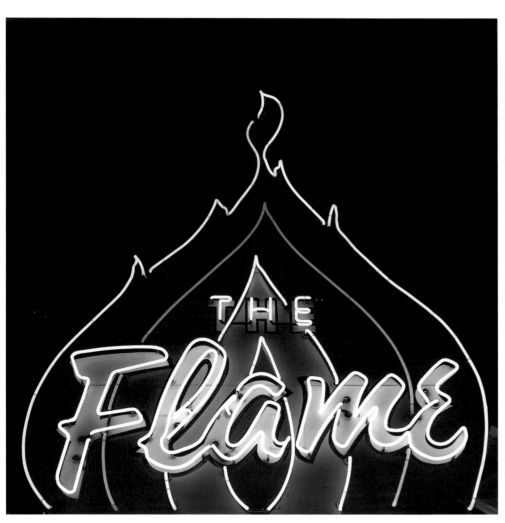

▲ The Flame Restaurant sign,
designed by Hermon Boernge, was first installed
in 1961 on the roof of the restaurant at #1 Desert Inn Road.
▶ Ninety feet above Fremont Street, the light show stretches 1,400
feet and consists of more than 12 million synchronized LED modules,
including 180 strobes and eight robotic mirrors per block.

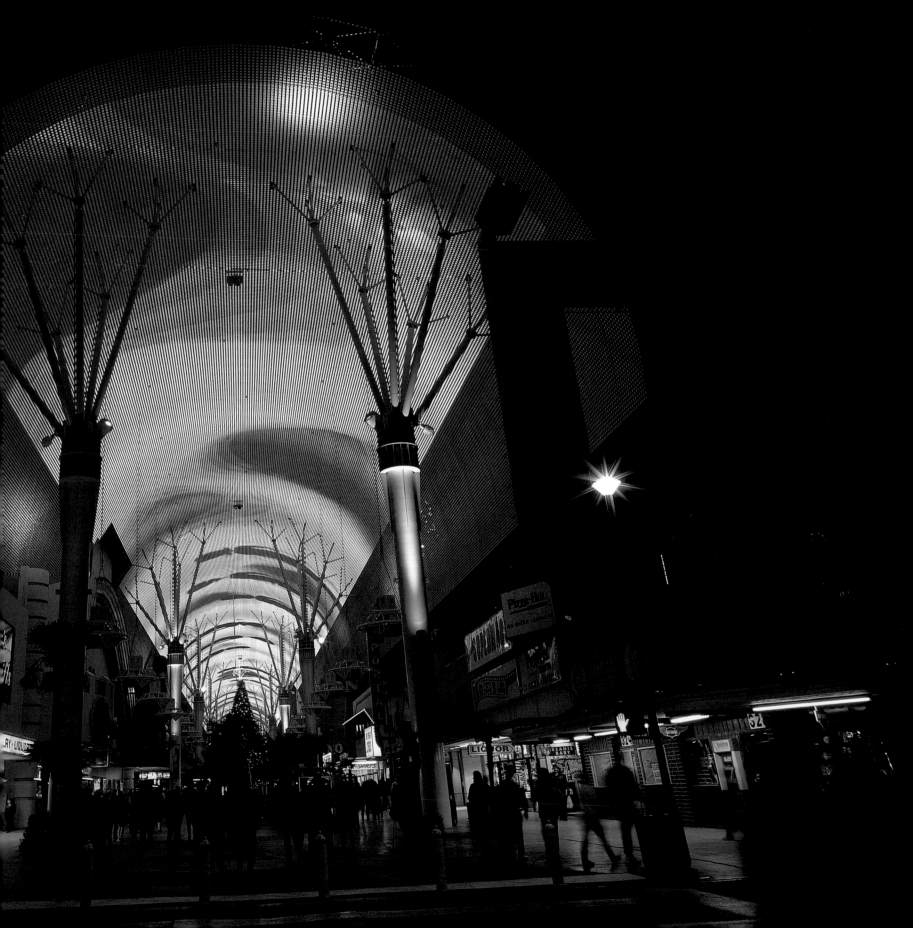

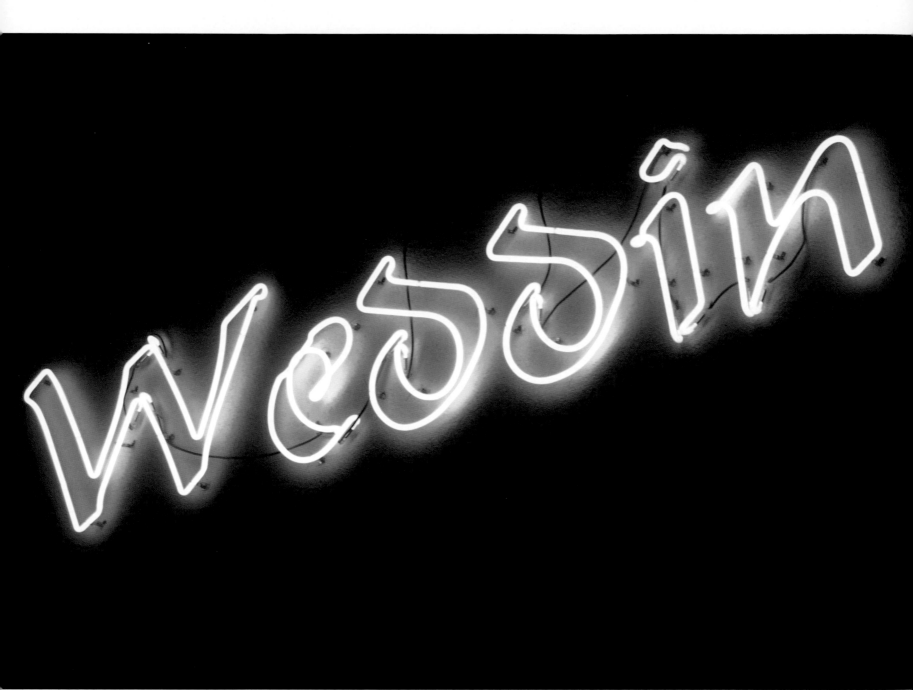

▲ Touted as the Wedding Capital of the World,
Las Vegas has issued more than 100,000 wedding licenses
each year since 1995. With a population of 376,000,
that would equal every citizen of the city getting
married about every four years.

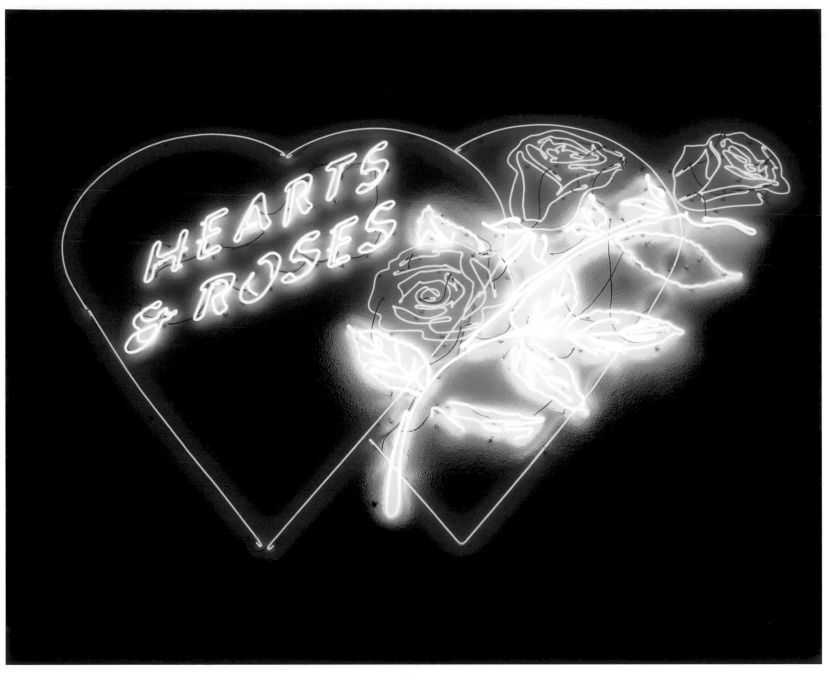

▲ Both at wedding chapels and
throughout the casinos and hotels, romance
is synonymous with Las Vegas.

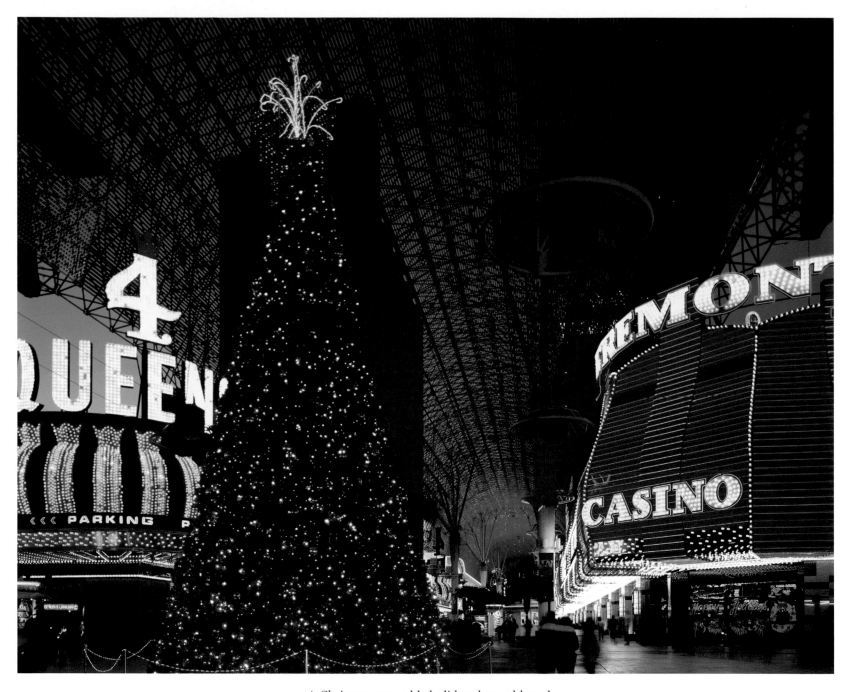

▲ A Christmas tree adds holiday cheer, although
its lights hardly make a dent against the brilliance of Las Vegas.
► The *Splash* neon lights the entrance to the Riviera Hotel
and Casino, a center for Las Vegas entertainment
for more than fifty years.

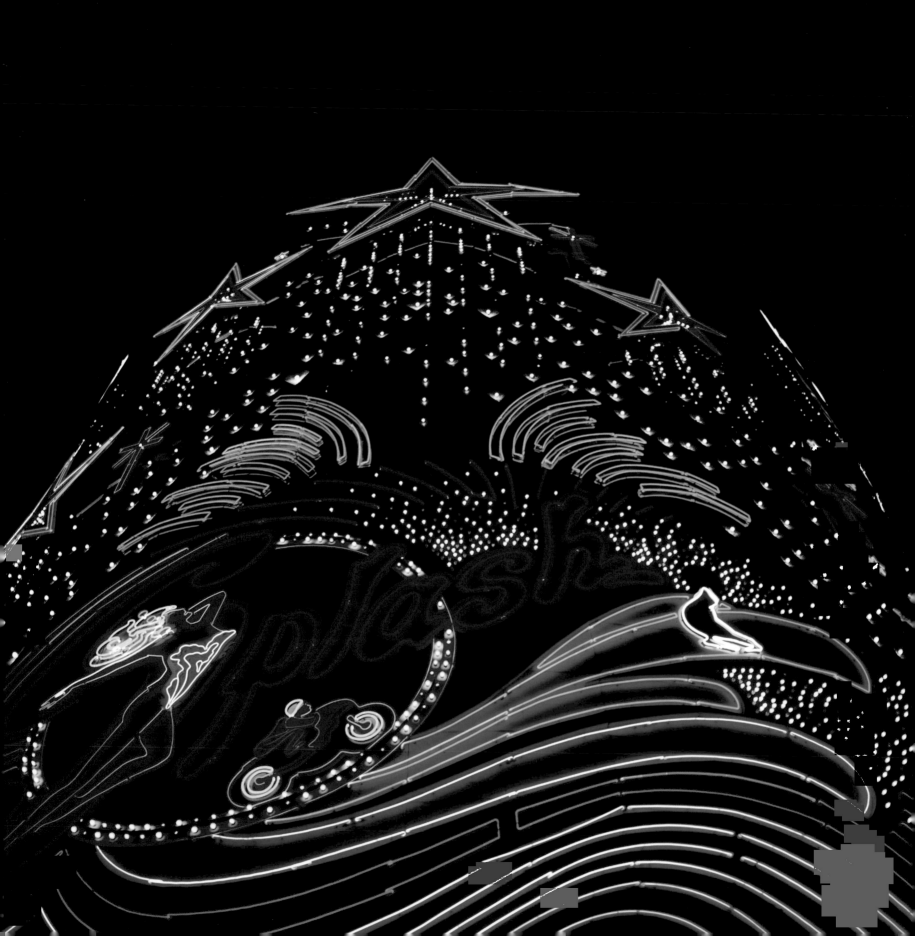

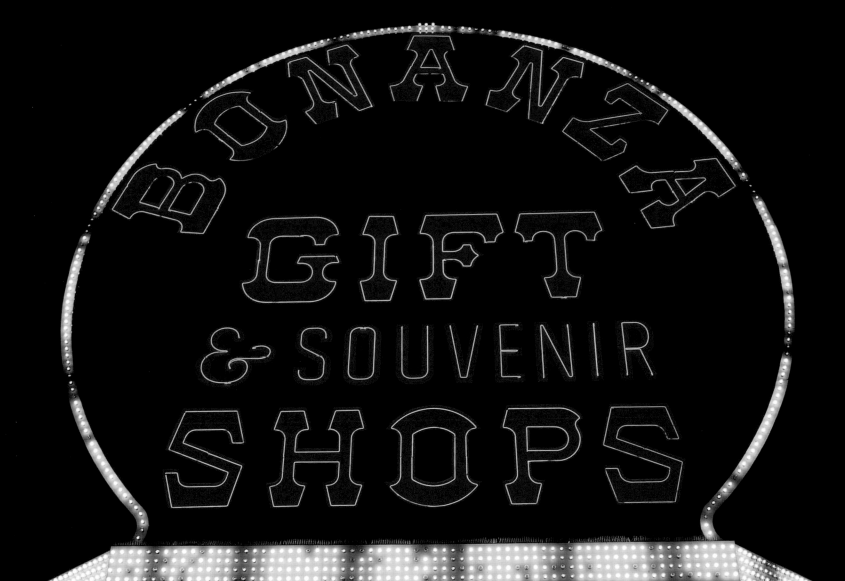

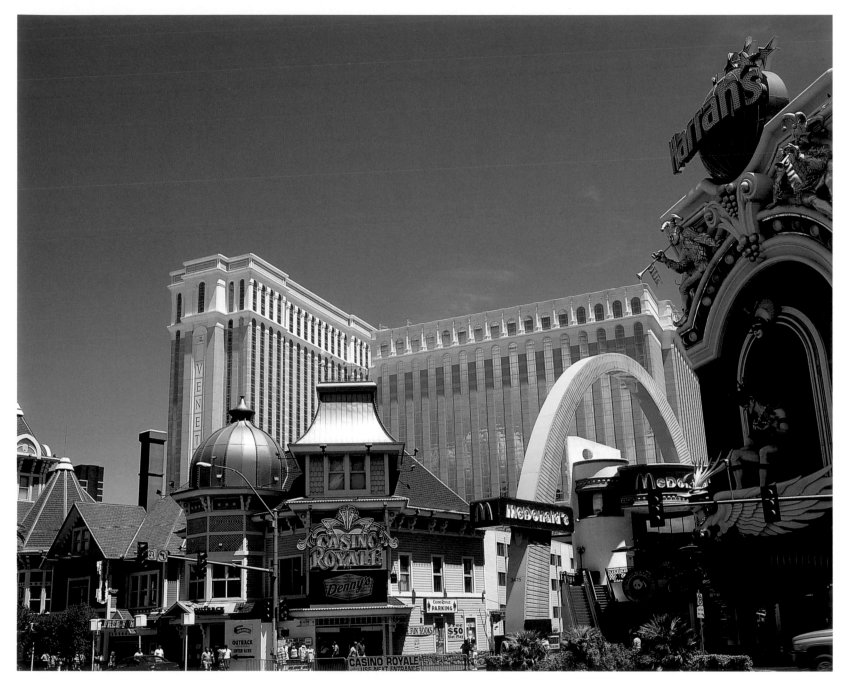

◄ On-site and online shopping
combine to ensure that the Bonanza, touted
as the world's largest gift shop, lives up to its name.
▲ McDonald's arches are everywhere, but these arches have
a special backdrop—the bright colors of Las Vegas.

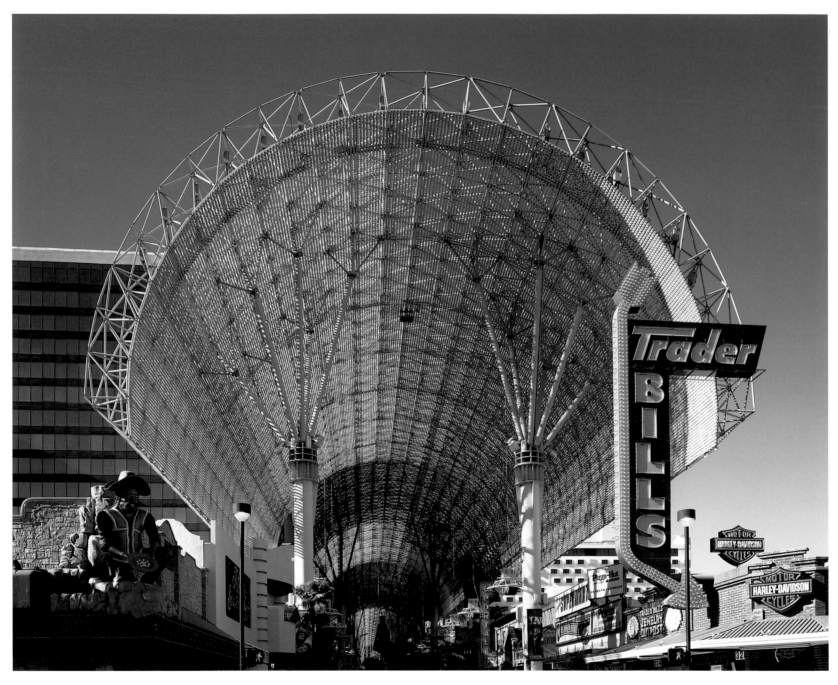

▲ Fremont Street seems sleepy
as it waits for night to bring it alive with
lights, music, and sound effects.

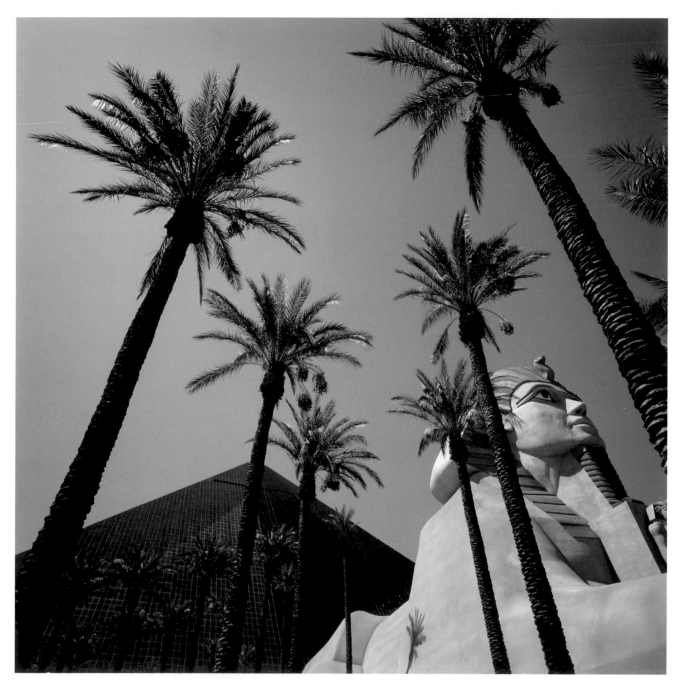

▲ The Luxor, the only sphinx-guarded pyramid
on the Strip, is named for an Egyptian city in upper Egypt.
It features a full-scale reproduction of King Tut's Tomb.

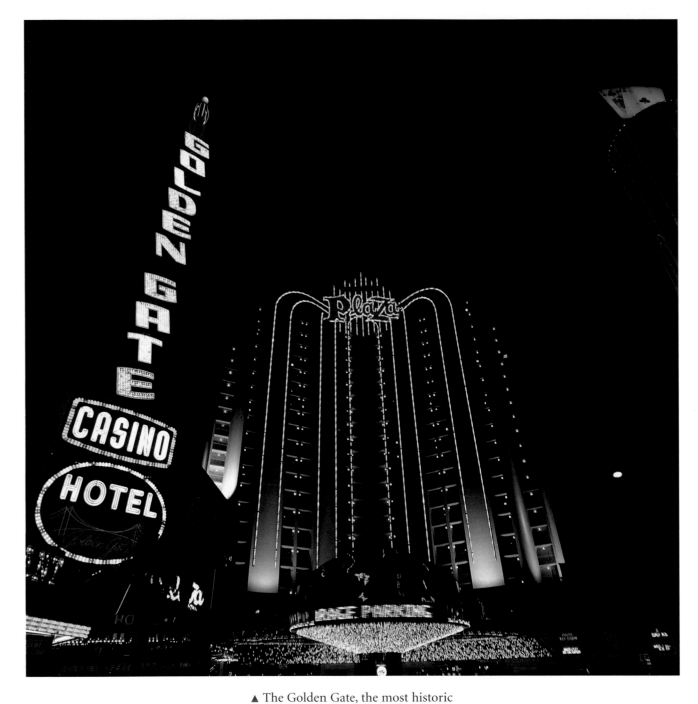

▲ The Golden Gate, the most historic
hotel and casino in Las Vegas, was established in 1906.
▶ The New Frontier Las Vegas is in the center of everything—
near the Fashion Show Mall, adjacent to the Sands Expo,
and close to the Las Vegas Convention Center.

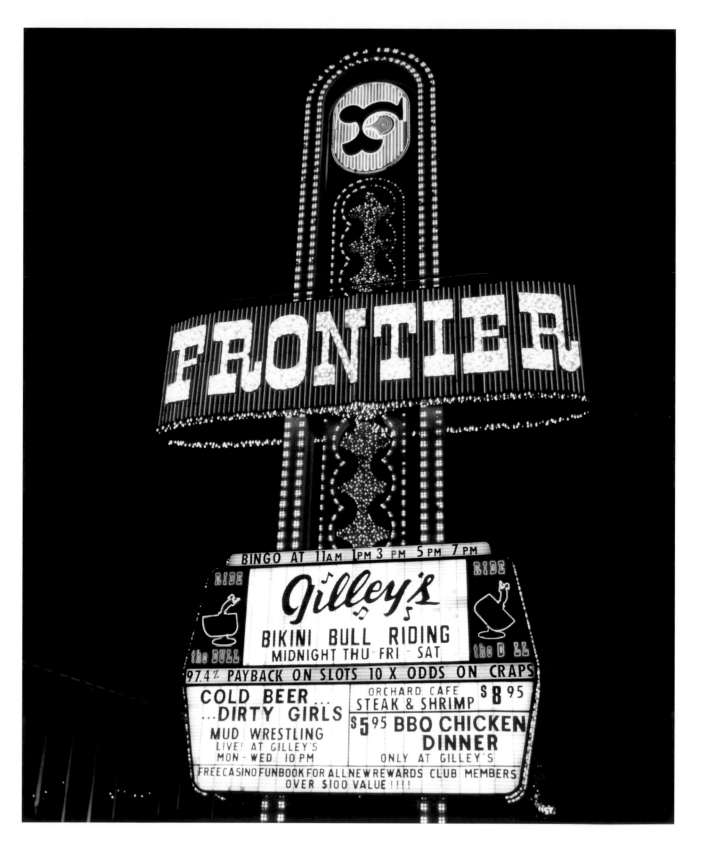

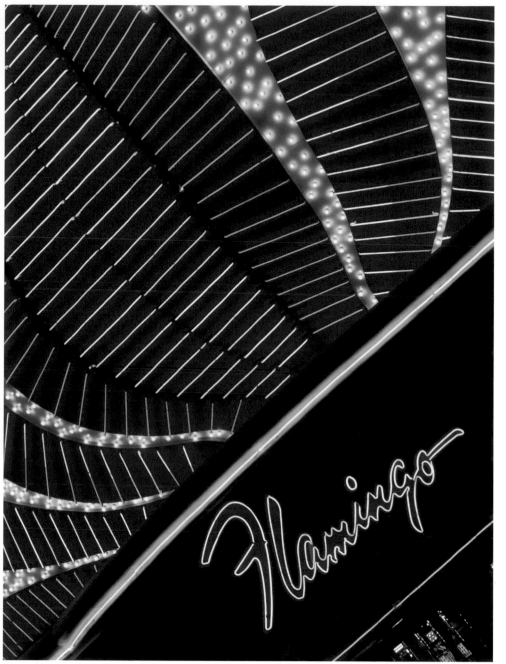

◄ The Flamingo's fifteen-acre pool area, which
embraces four pools, is part of the Wildlife Habitat.
▲ Featuring entertainment, restaurants, meeting and convention
accommodations, and world-class gaming, the Flamingo
is situated on the famous four corners of Las Vegas
Boulevard and Flamingo Road.

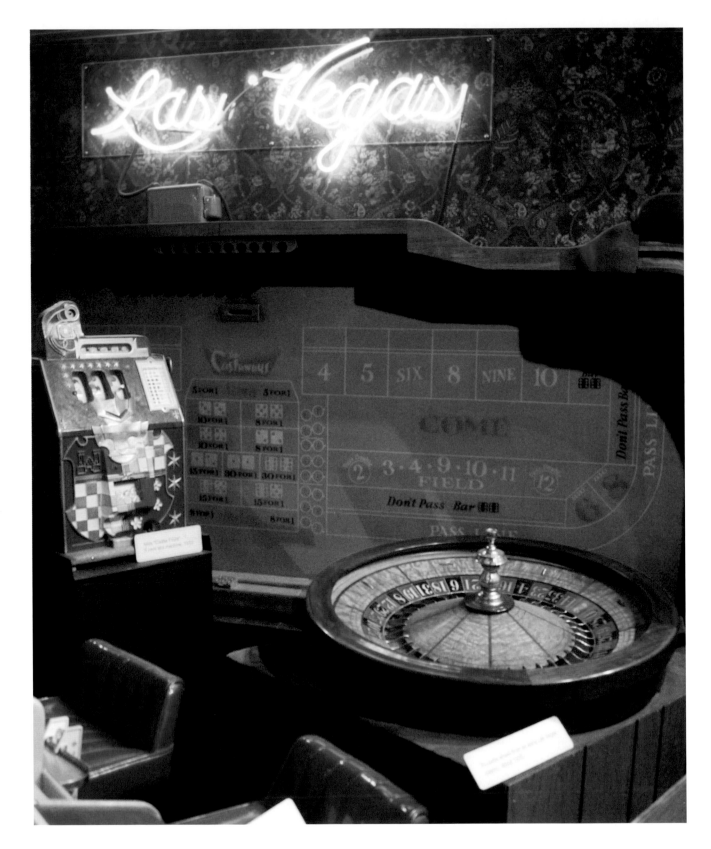

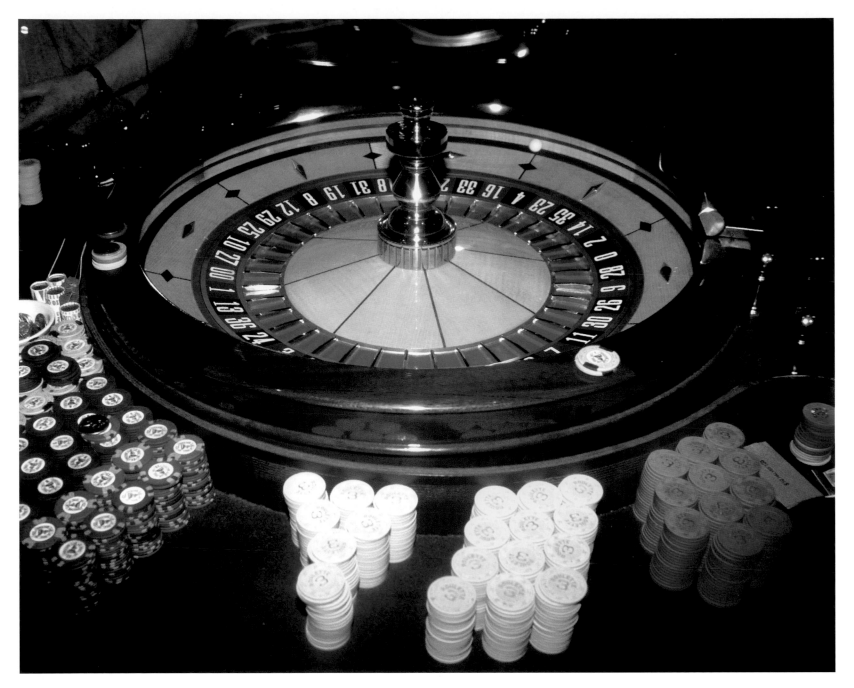

◄ The Clark County Museum includes
exhibits, restored historic structures, and ghost
towns. The old-style Roulette wheel is easily recognizable.
▲ One of the easiest games to play and understand is Roulette. But the
easier a game is to understand the greater the house edge.

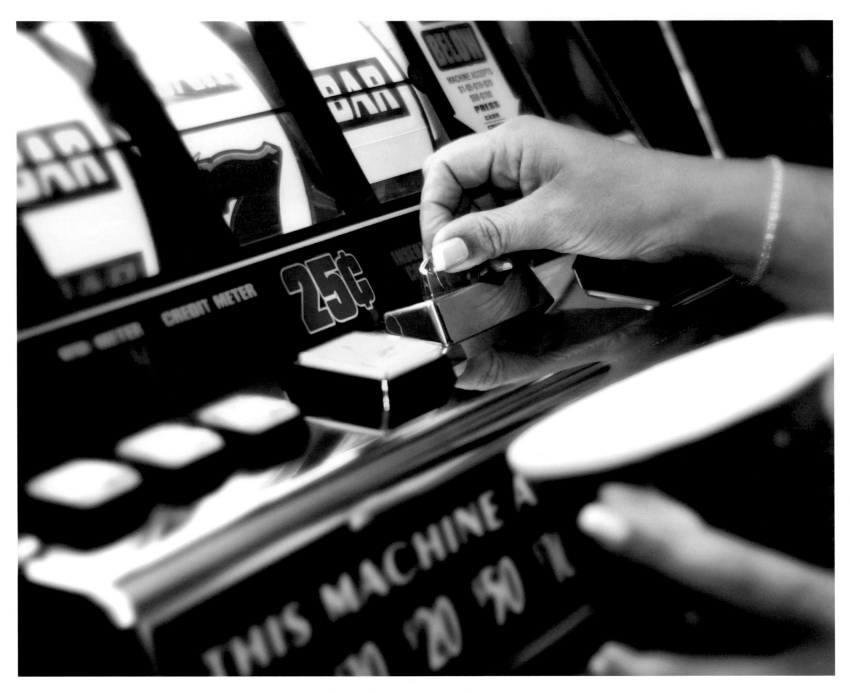

▲ Slot machines are one of the most
popular attractions in casinos. Las Vegas claims that
there is a slot machine for every eight residents.
► A blackjack table awaits players, its chairs
"dressed" to face backwards.

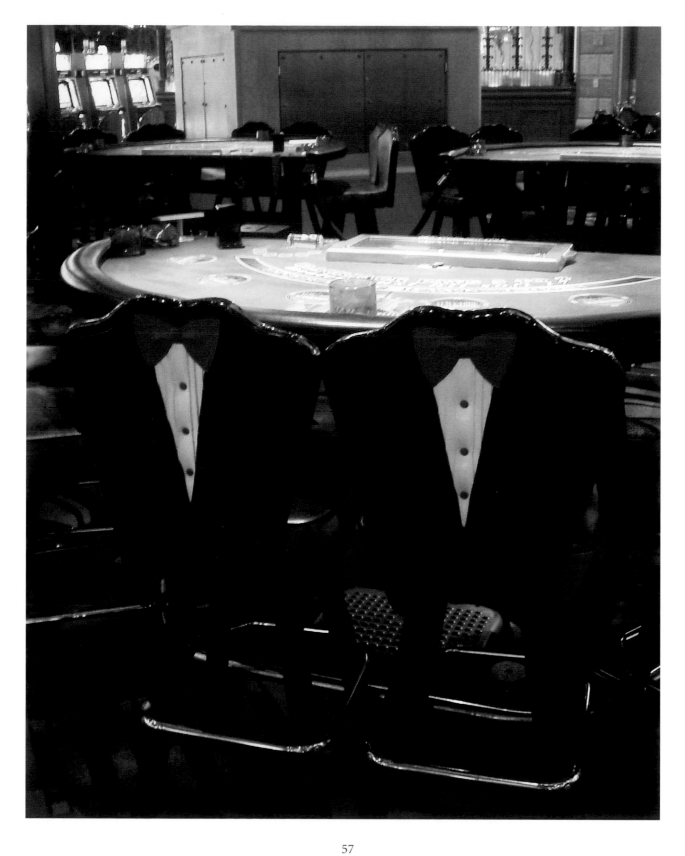

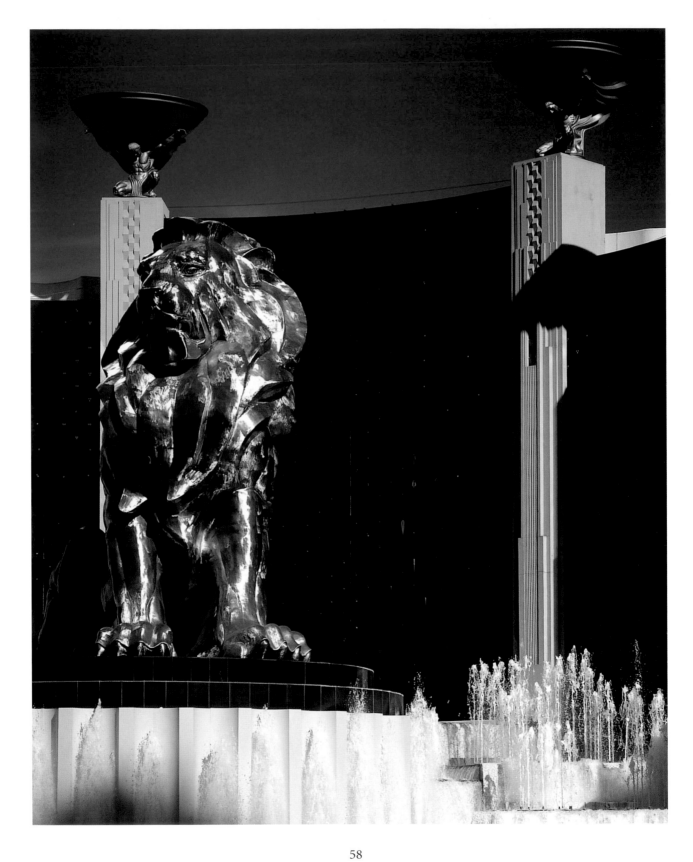

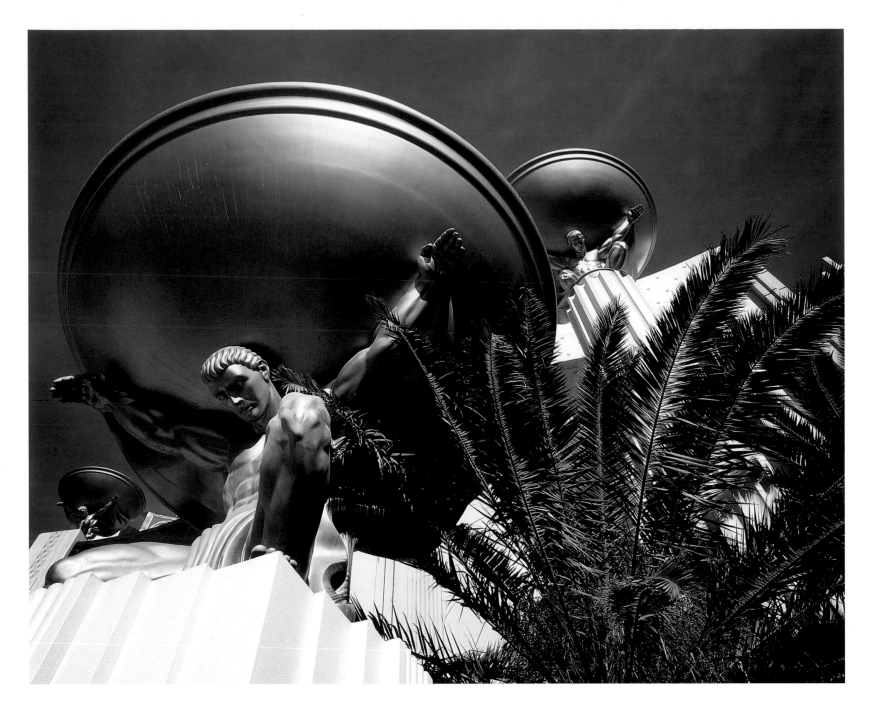

◄ A statue of a lion rests atop a twenty-five-
foot pedestal above the MGM fountain; weighing fifty
tons, it is the largest bronze sculpture in the United States.
▲ The MGM Grand entrance also features ten-foot-tall winged
figures of Atlas-like men holding bowls sixteen feet across.
Each houses brilliant light beams that project skyward.

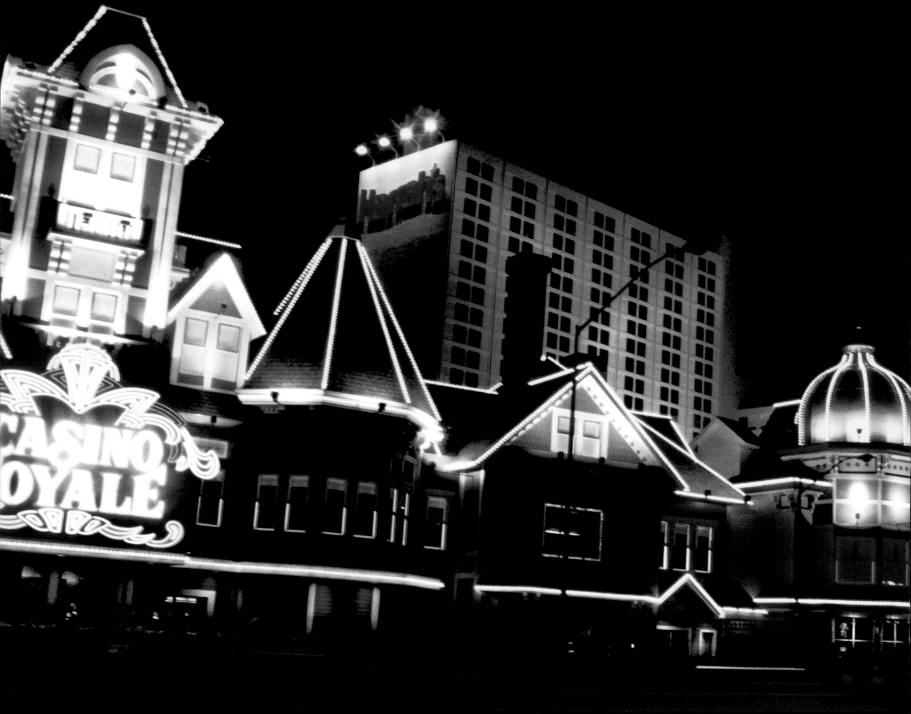

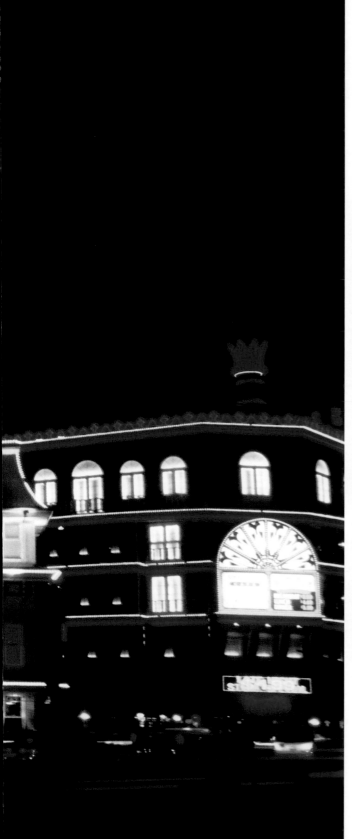

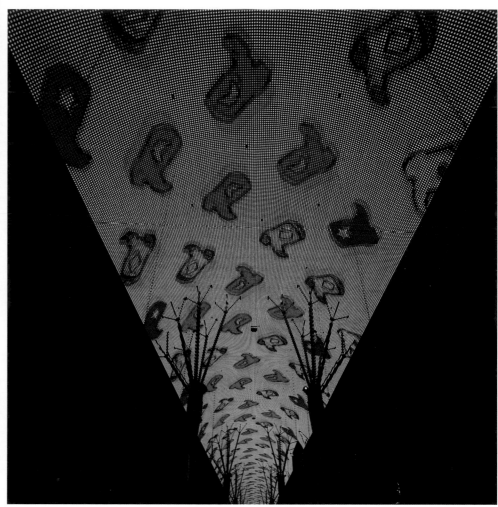

◄ A fairy-tale city seems to have
sprung up with every building "dressed" in neon.
▲ Part of the Fremont Street Experience, the free light show
can switch from a swirling ocean setting to a
television broadcast in minutes.

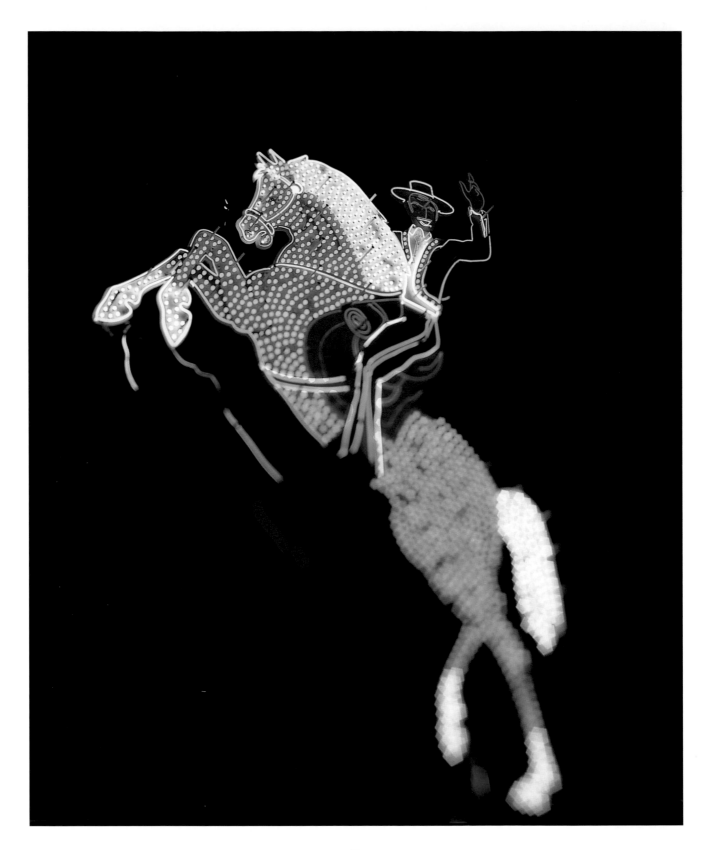

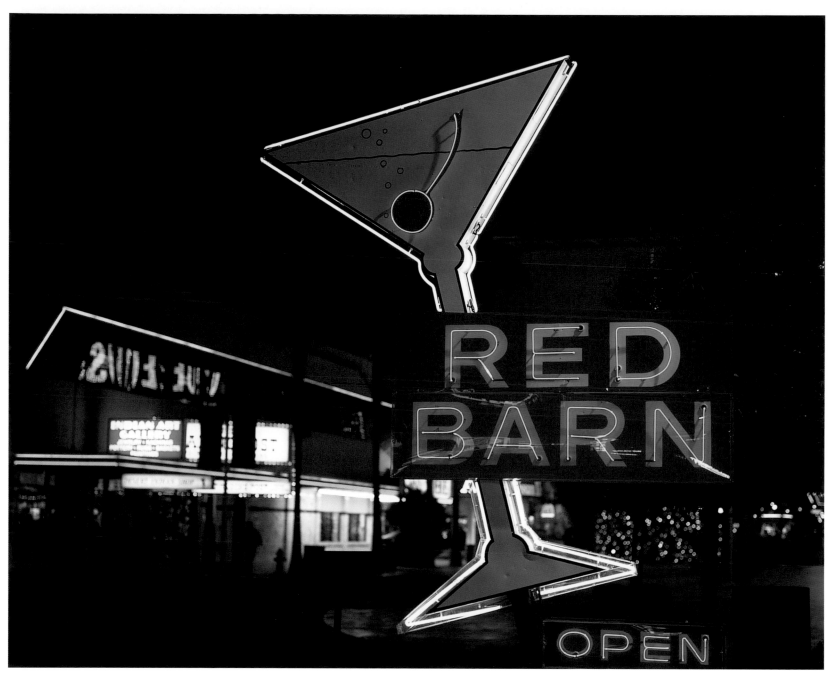

◄ The *Hacienda Horse* was originally
installed in 1967 at the Hacienda Hotel. It was the first
neon sign to be relocated and put on display on Fremont Street.
▲ The *Red Barn* neon martini glass dates from the 1960s. When the
Red Barn bar burned to the ground, the sign was saved. It was
restored by the Neon Museum and installed in 2000.

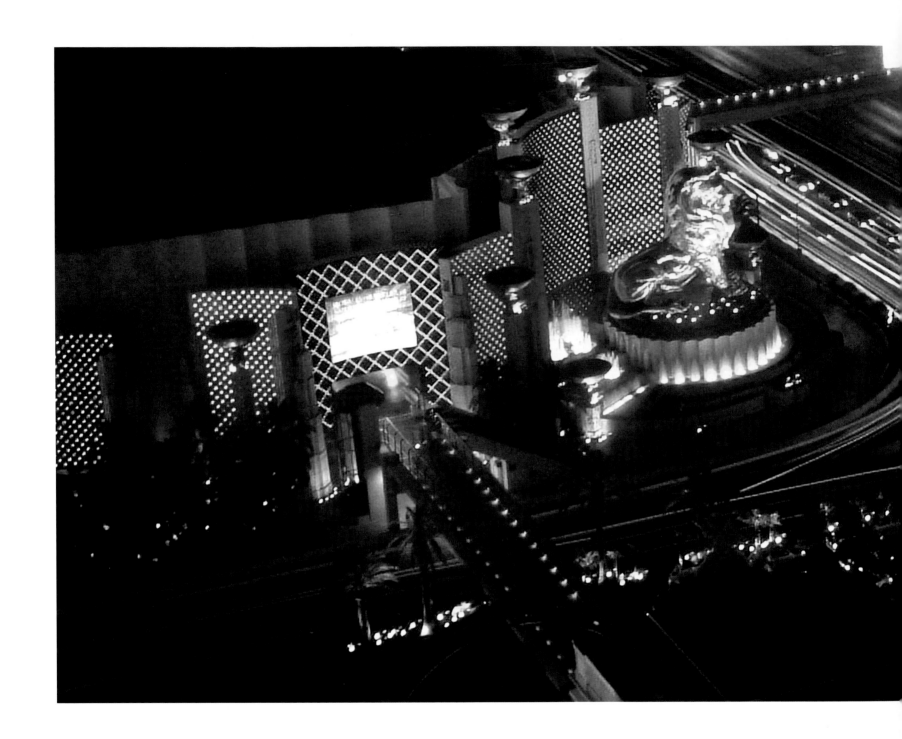

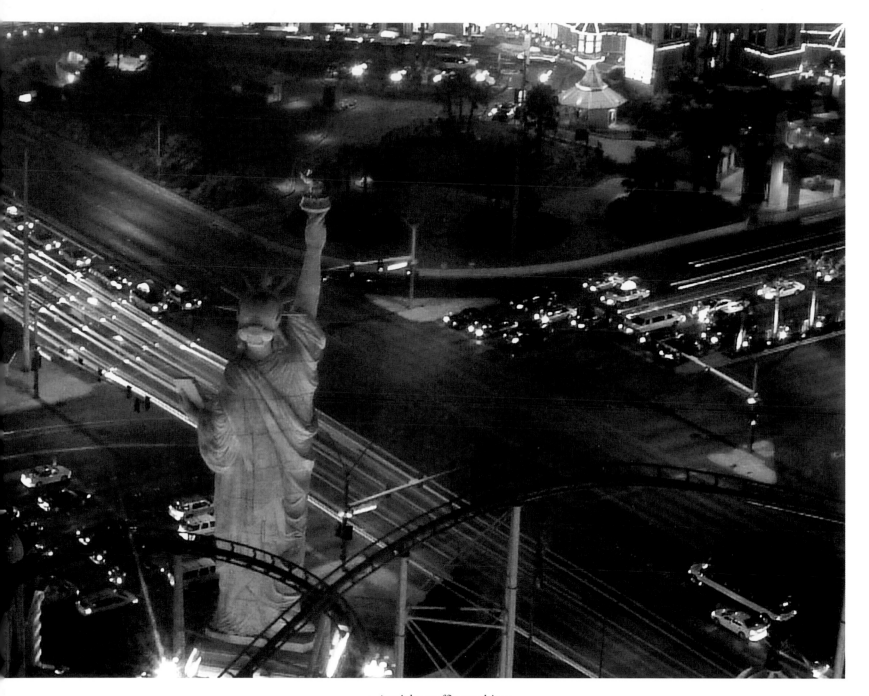

▲ At night, traffic combines
with the city's neon lights to
present a romantic look that belies the
busyness of playing and gaming.

▲ Lights of the MGM Grand silhouette a palm tree.
Situated directly across from the New York-New York Hotel,
the $1 billion, 5,034-room MGM Grand resort offers every type
of show from *La Femme* to Cirque du Soleil's *KÀ*.

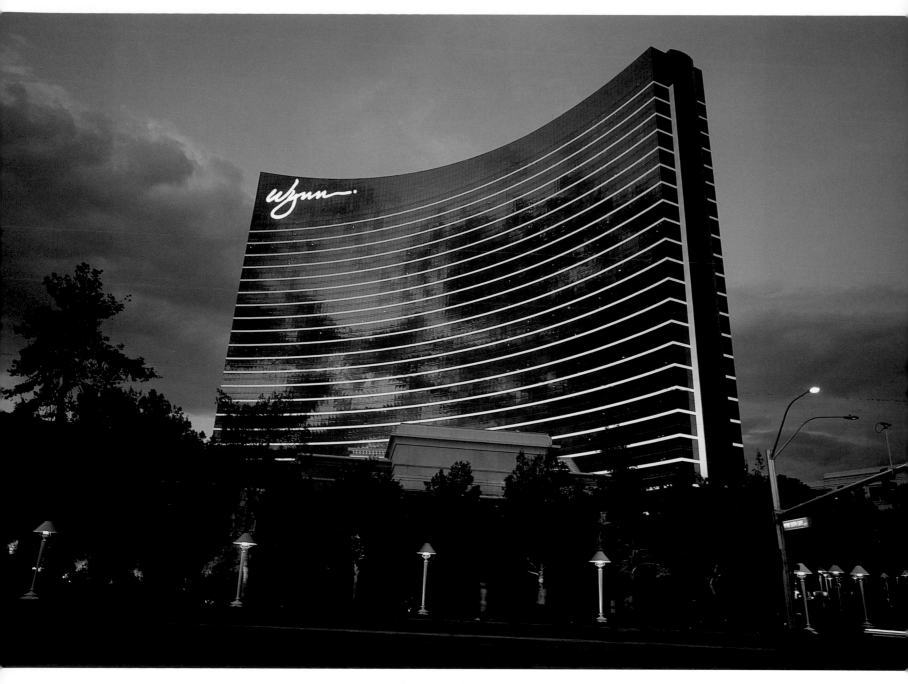

▲ Designer boutiques, innovative spa
treatments, stunning shows, professional fights, and
fine dining are only a few of the offerings at the Wynn Las Vegas.
►► After heralding the Aladdin Hotel for thirty-one years, the thirty-five-
foot-long Aladdin's Lamp is now part of the Neon Museum.

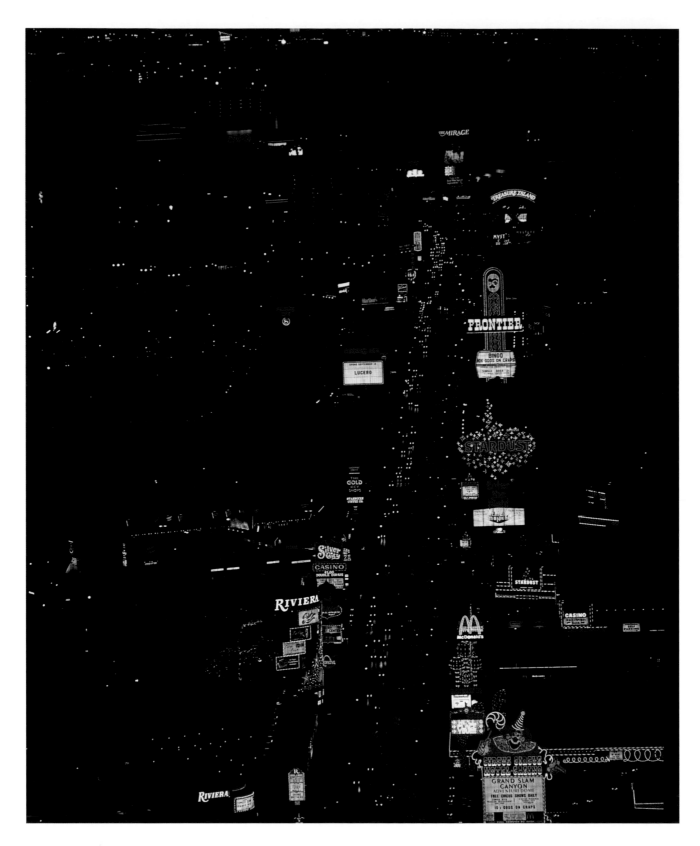

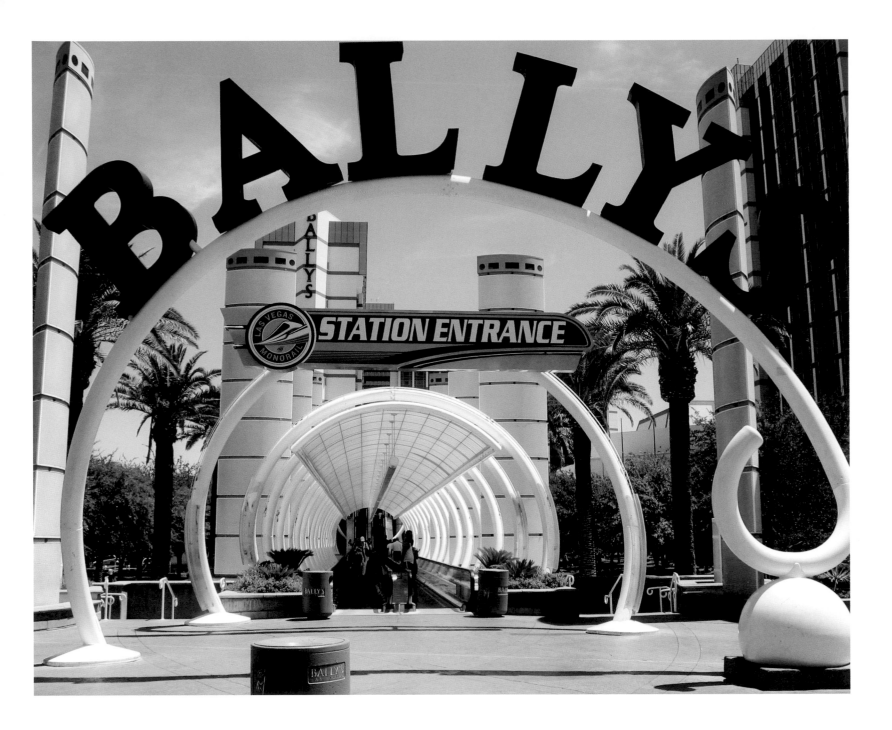

◄ The view from the 1,149-foot, 108-story Stratosphere,
the tallest structure west of the Mississippi River, is stunning.
▲ The Monorail entrance at Bally's hints at the opulence in the
hotel, which offers convention accommodations along with gaming.
►► Day trips from Las Vegas offer variety. Located approximately thirty
miles east of the city, Lake Mead is the nation's largest man-made lake.

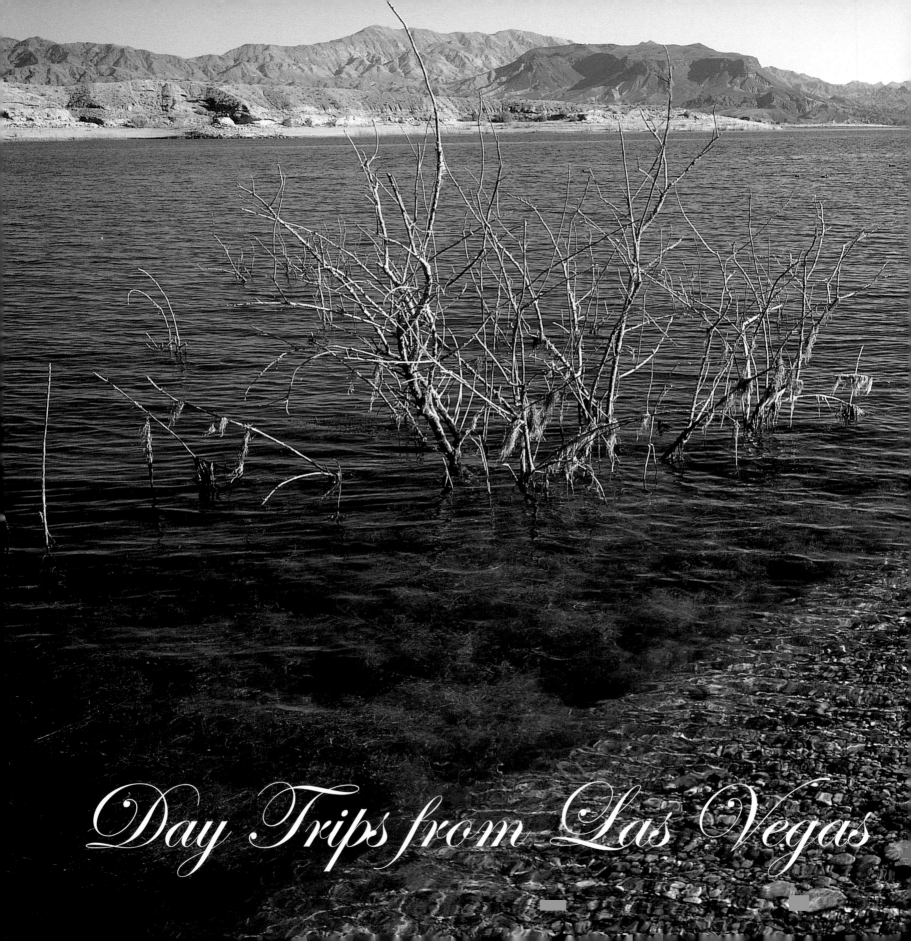

Day Trips from Las Vegas

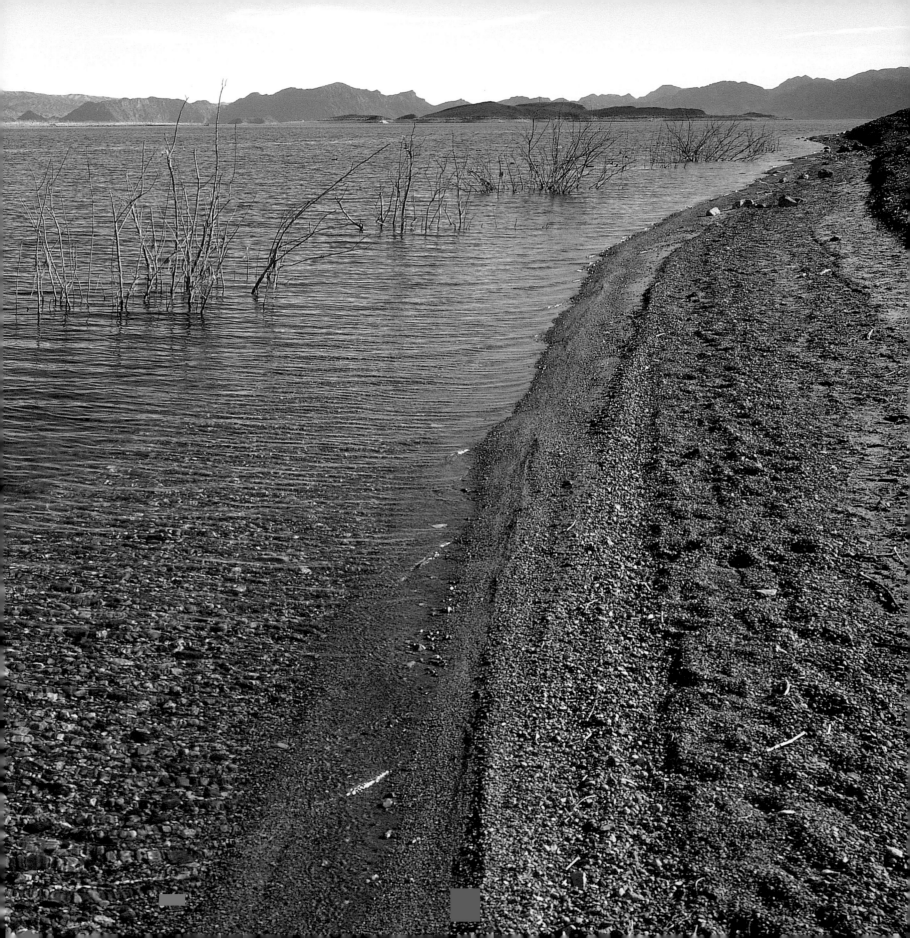

▲ The Gail Hills rise in the Lake Mead
National Recreation Area. Three of America's five
desert ecosystems—the Mojave, the Great Basin, and the
Sonoran Deserts—meet in Lake Mead National Recreation Area.
As a result, this seemingly barren area contains a surprising
variety of plants and animals, some of which may
be found nowhere else in the world.

▲ Lake Mead flooded a vast area of desert,
covering many canyons, relics of ancient settlements,
and several small villages, including St. Thomas, Nevada, the ruins of
which are occasionally visible when the lake's water level is low.
▶▶ The North Shore Drive along Lake Mead
offers stunning scenic vistas.

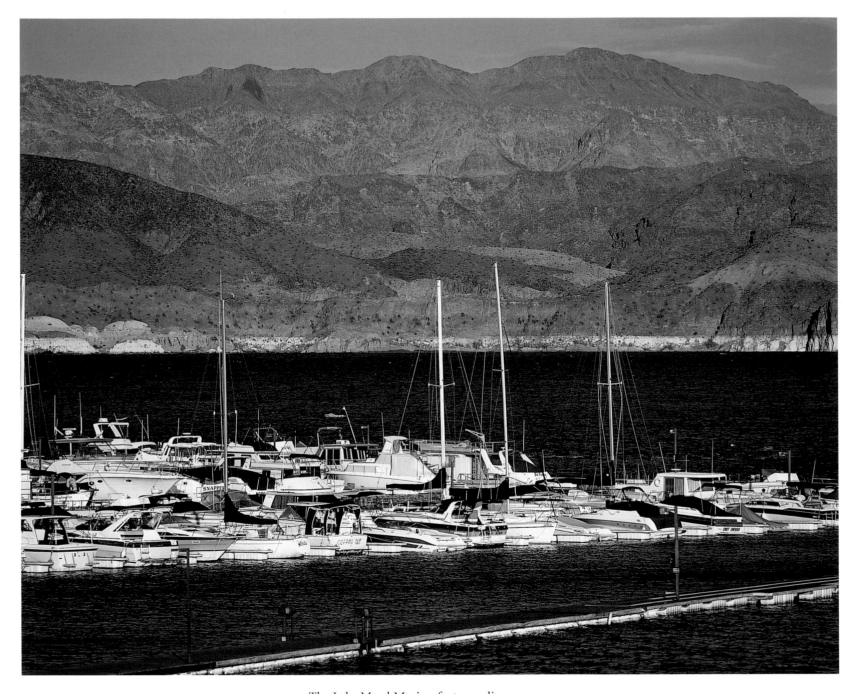

▲ The Lake Mead Marina features slips, moorage,
repair facilities, and a gas dock. Other amenities include a
lodge, a resort, and a swimming pool, as well as boat rental availability.
► Scenic vistas abound in the Black Hills around Lake Mead.

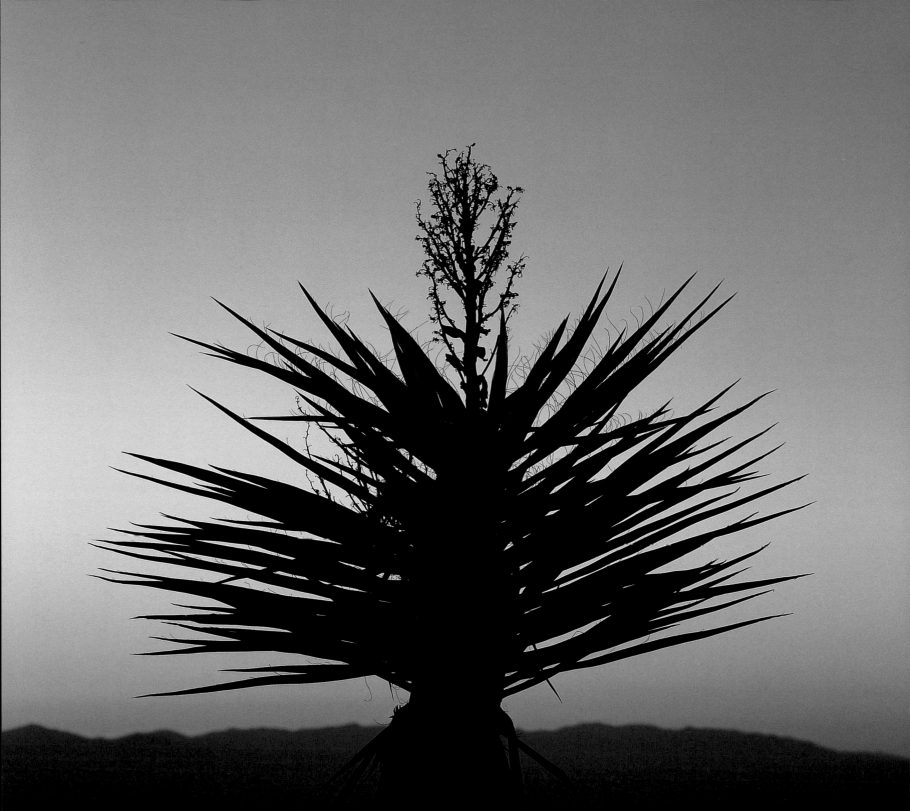

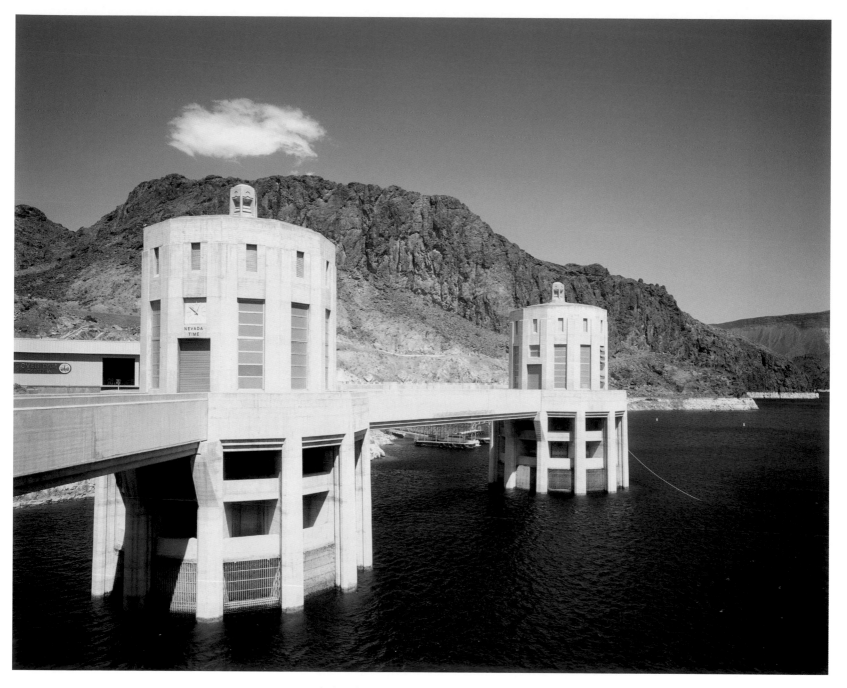

◄ Sunset light silhouettes a yucca at Christmas Tree Pass.
Located in the southwest corner of the Lake Mead Recreation
Area, Christmas Tree Pass embraces rock formations enjoyed by climbers.
▲ A curved gravity dam, Hoover Dam has two huge intake towers on each side.
Built during the Depression, it took just five years to construct. Rated by the
American Society of Civil Engineers as one of America's Seven Modern
Civil Engineering Wonders, the dam is a National Historic Landmark.

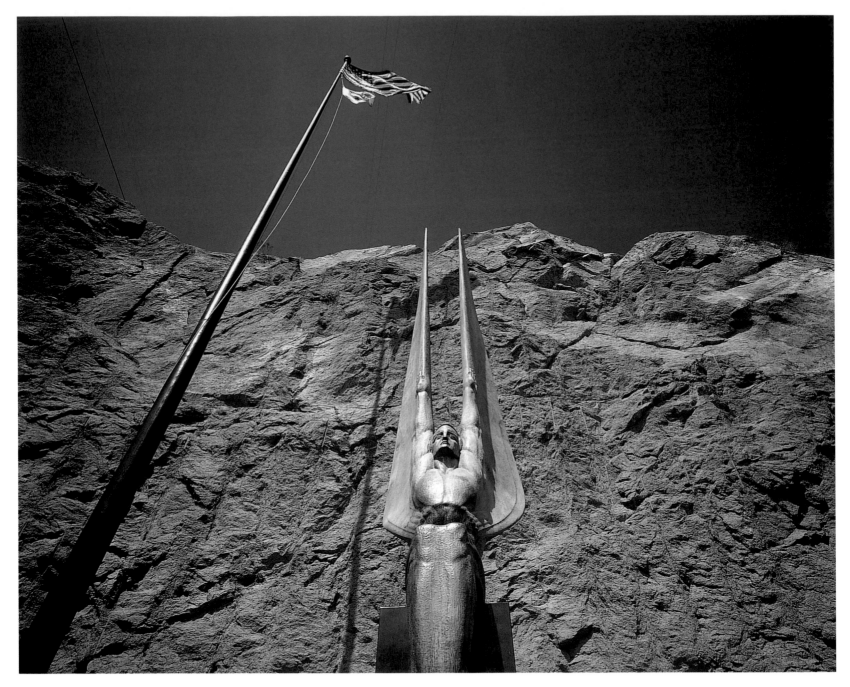

▲ *Winged Figures of the Republic* were created by
Norwegian-born, naturalized American Oskar J. W. Hansen.
Meant to honor those who built Hoover Dam, they are "a monument to
collective genius exerting itself in community efforts around a common need or ideal."
► The power plant at Hoover can generate more than four billion kilowatt-hours a year.
►► A distance shot of the Black Hills from Lake Mead can't begin to show the beauty; it's better seen
by hiking, driving, biking, or boating as well as guided lake and Hoover Dam tours.

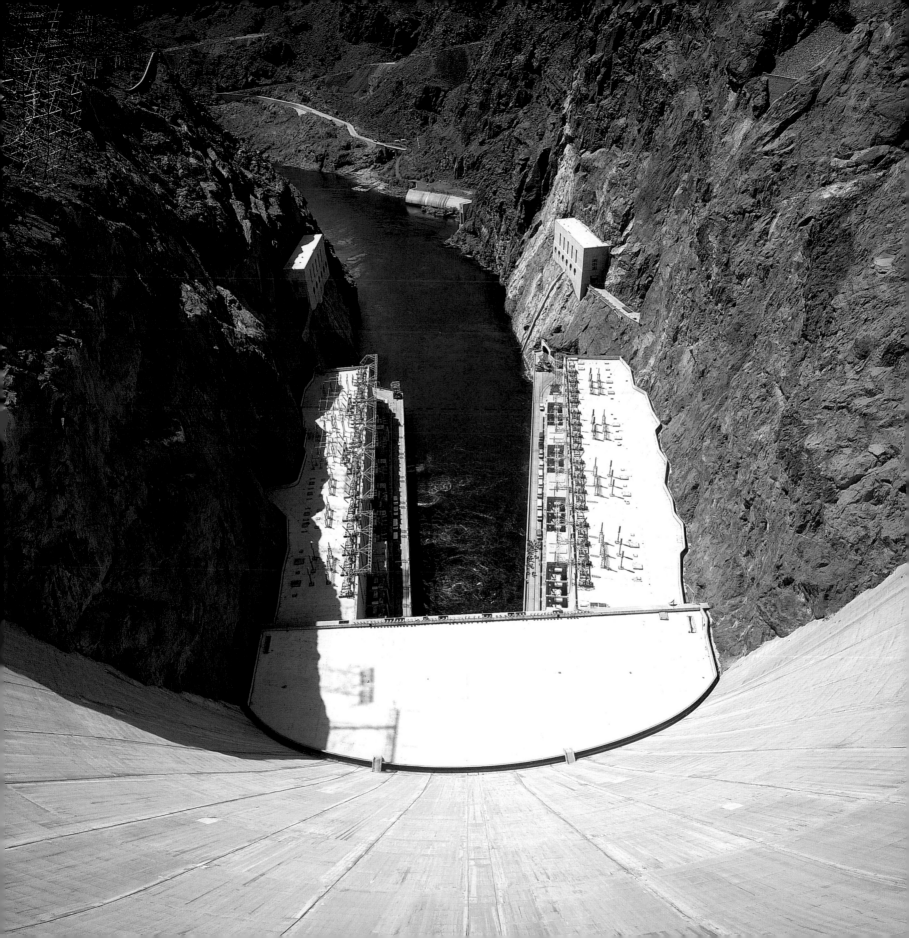

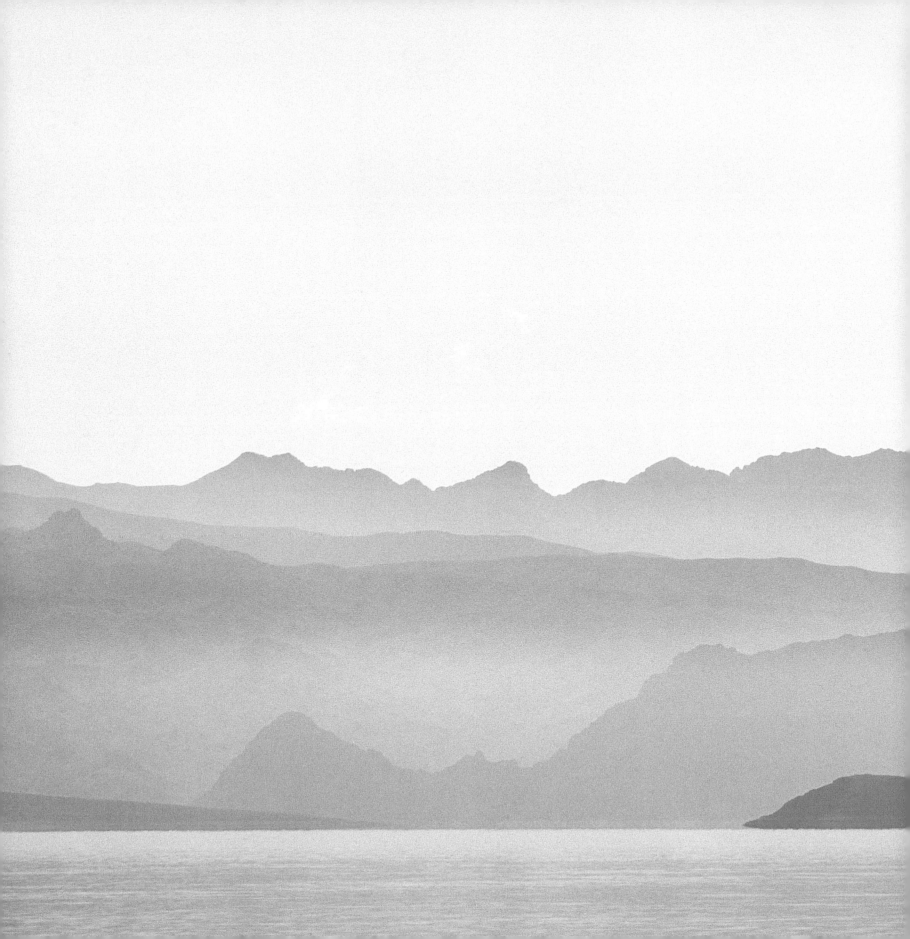

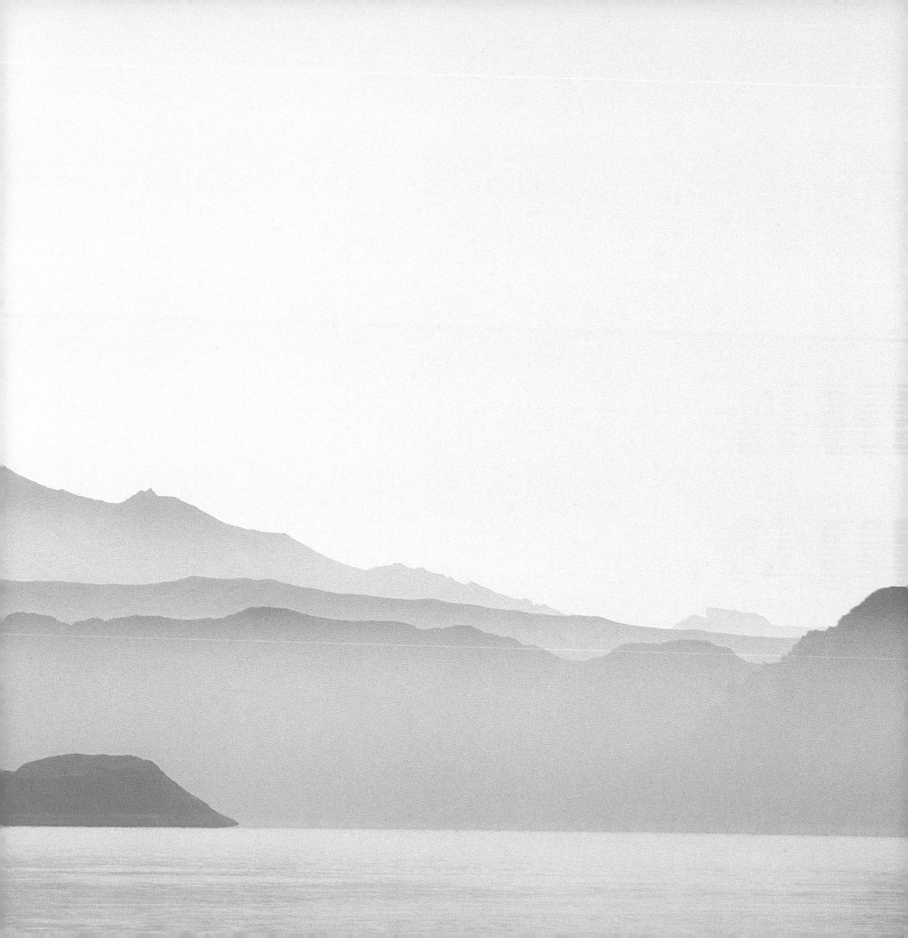

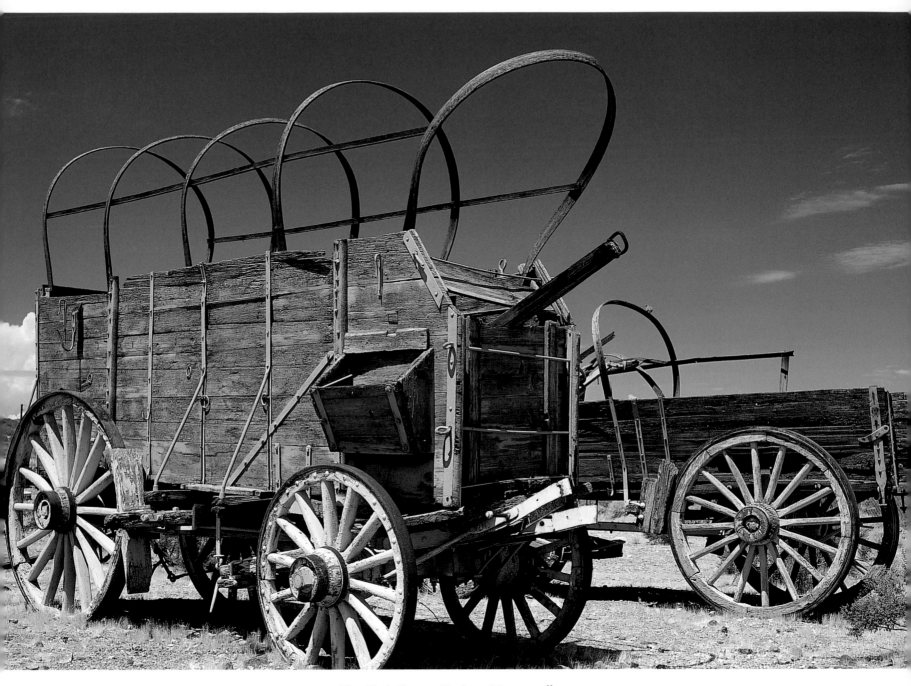

▲ The Clark County Heritage Museum allows you to
explore southern Nevada in a time line from the Pleistocene era
to the early casino atmosphere, including indoor and outdoor displays
covering twenty-five acres. Exhibits encompass an early slot machine, a mine,
Anasazi and Paiute camps, covered wagons, and other special themes.
▶ A ghost town on Heritage Museum land affords a glimpse
of those who lived here in years gone by.

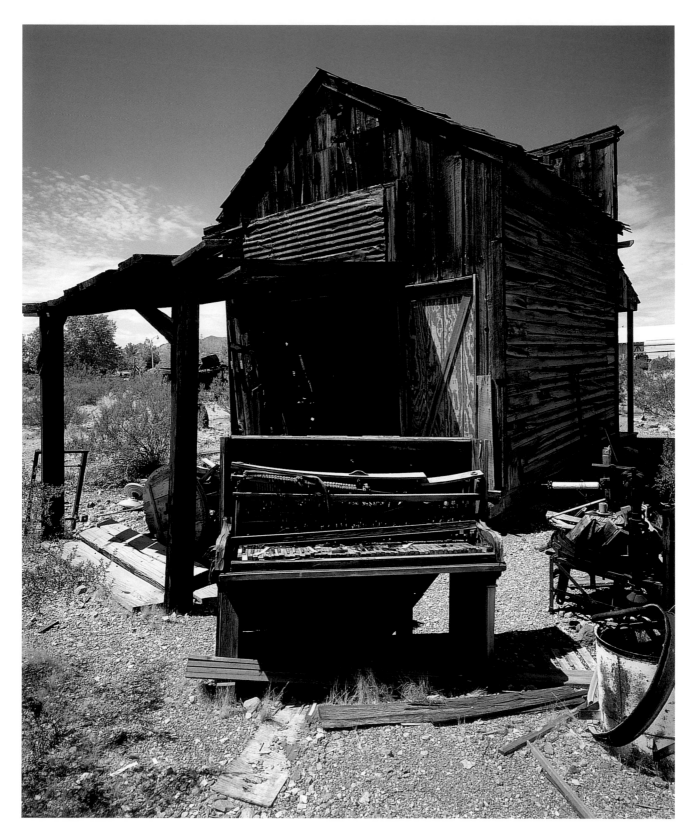

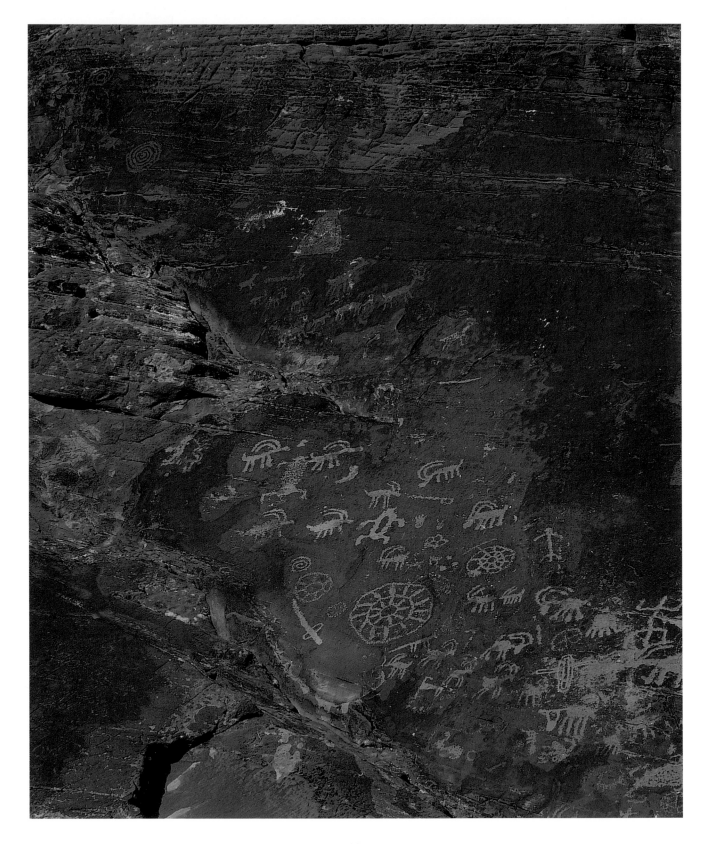

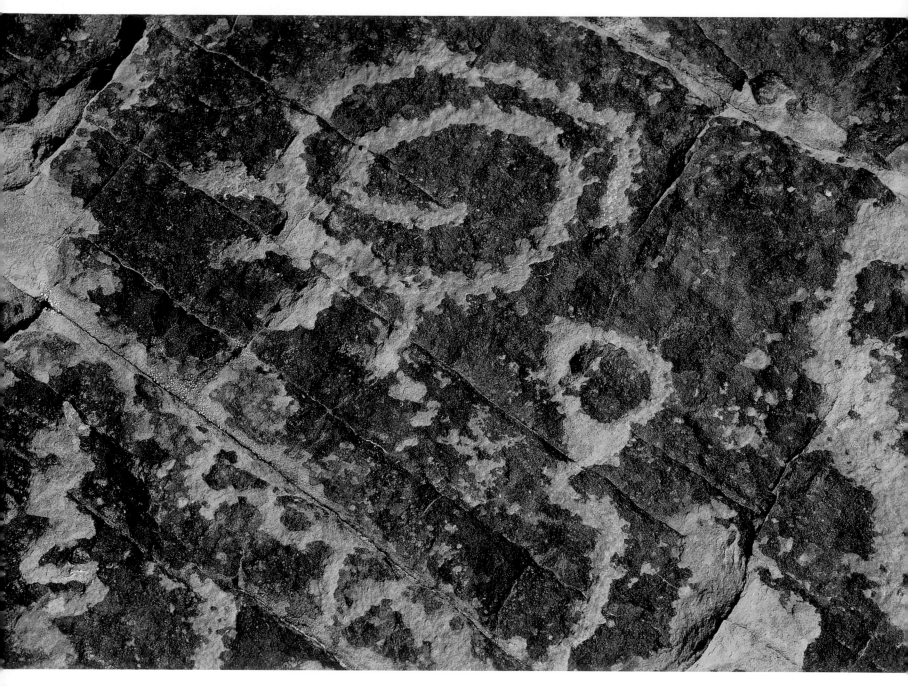

◄ Anasazi petroglyphs (rock carvings) display the
artistic talents of people who roamed the area nearly a thousand years ago.
▲ Valley of Fire State Park is home to Atlatl Rock, which depicts
numerous spear-throwing devices. The atlatl was a
predecessor to the bow and arrow.

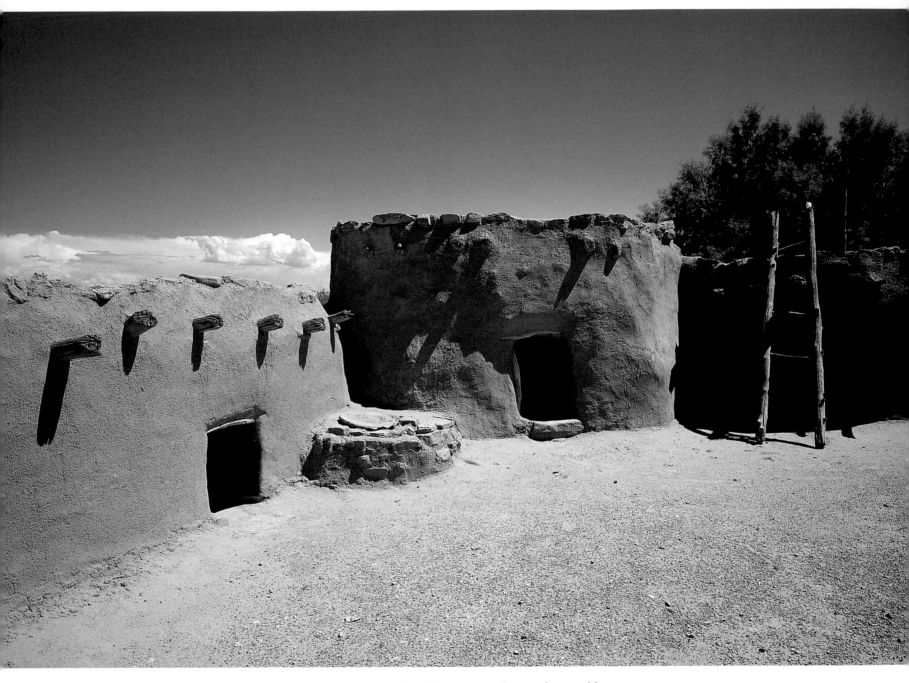

▲ Just north of Overton are thousand-year-old
Anasazi Indian pueblos, where buildings have been
reconstructed on the original foundations to portray
as accurately as possible the way things were when
the Anasazi Indian tribes roamed the land.

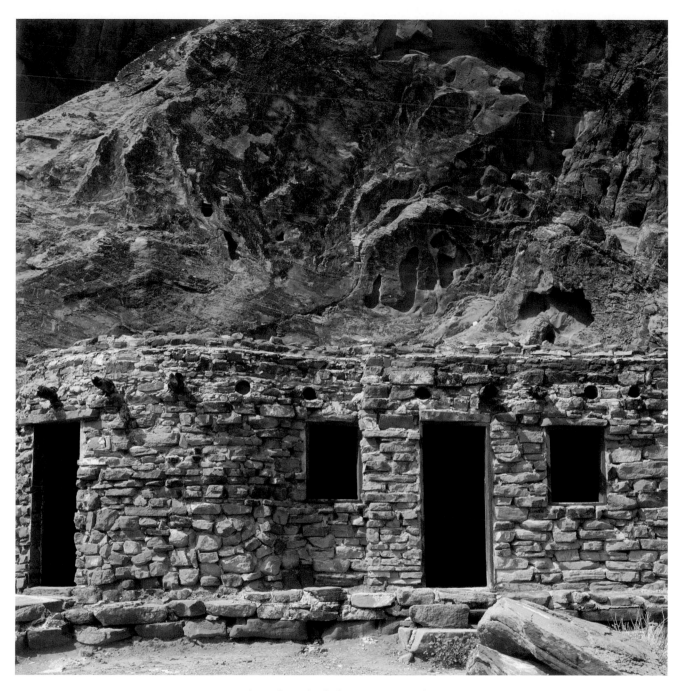

▲ The Cabins, built from native sandstone
in the Valley of Fire State Park, were constructed in
the 1930s by the Civilian Conservation Corps (CCC) as shelters
for passing travelers. The area is now utilized for picnics.

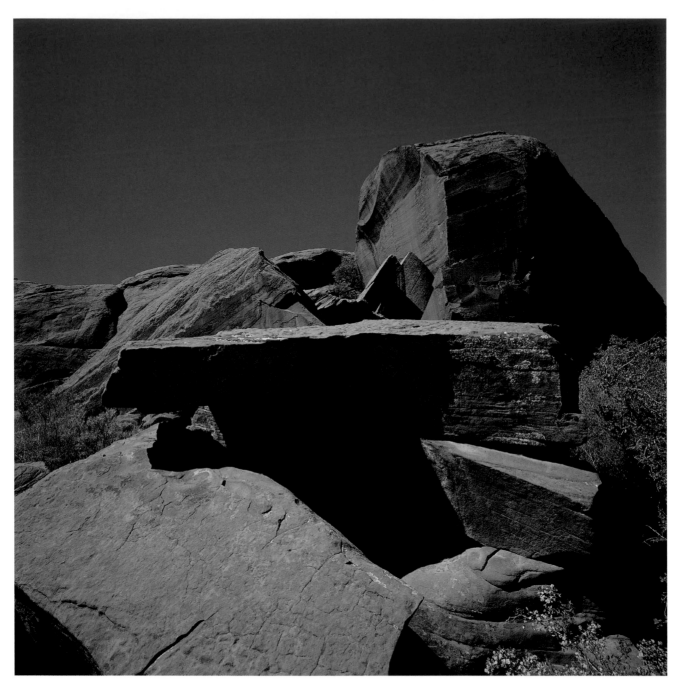

▲ The Calico Hills are a large
outcrop of eroded red sandstone rock.
► Excellent for serious climbers, the Calico
Hills also include overlooks and short
trails suitable for the less energetic.

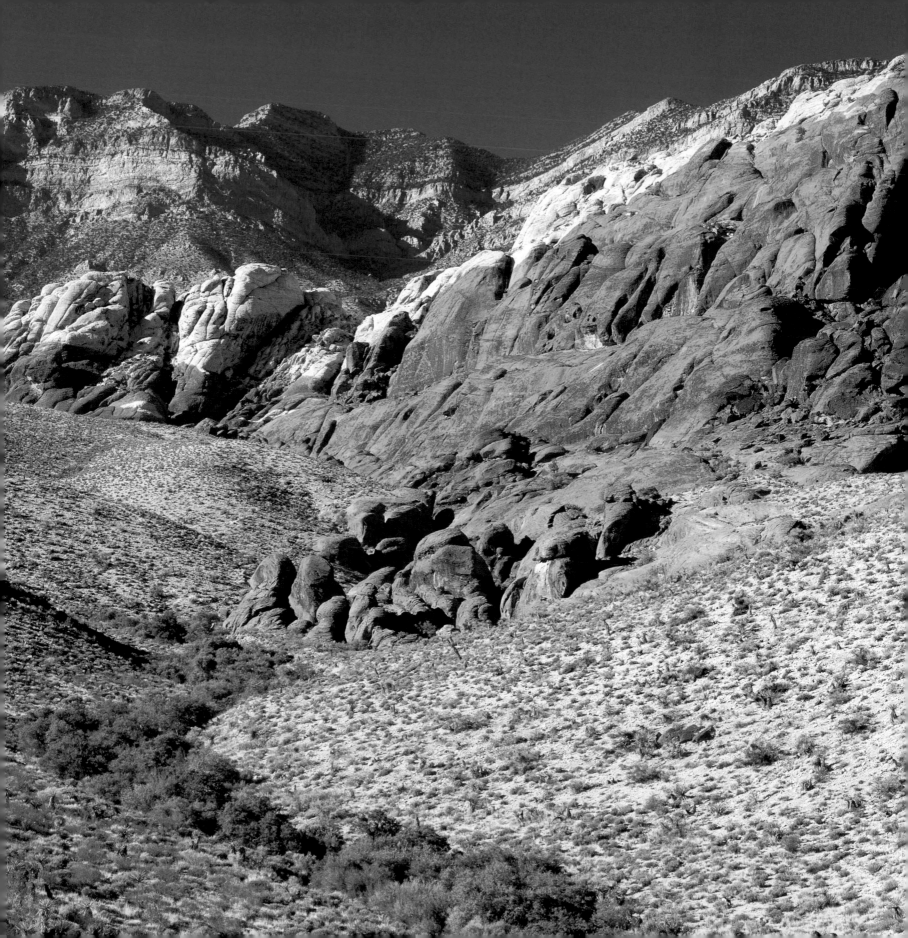

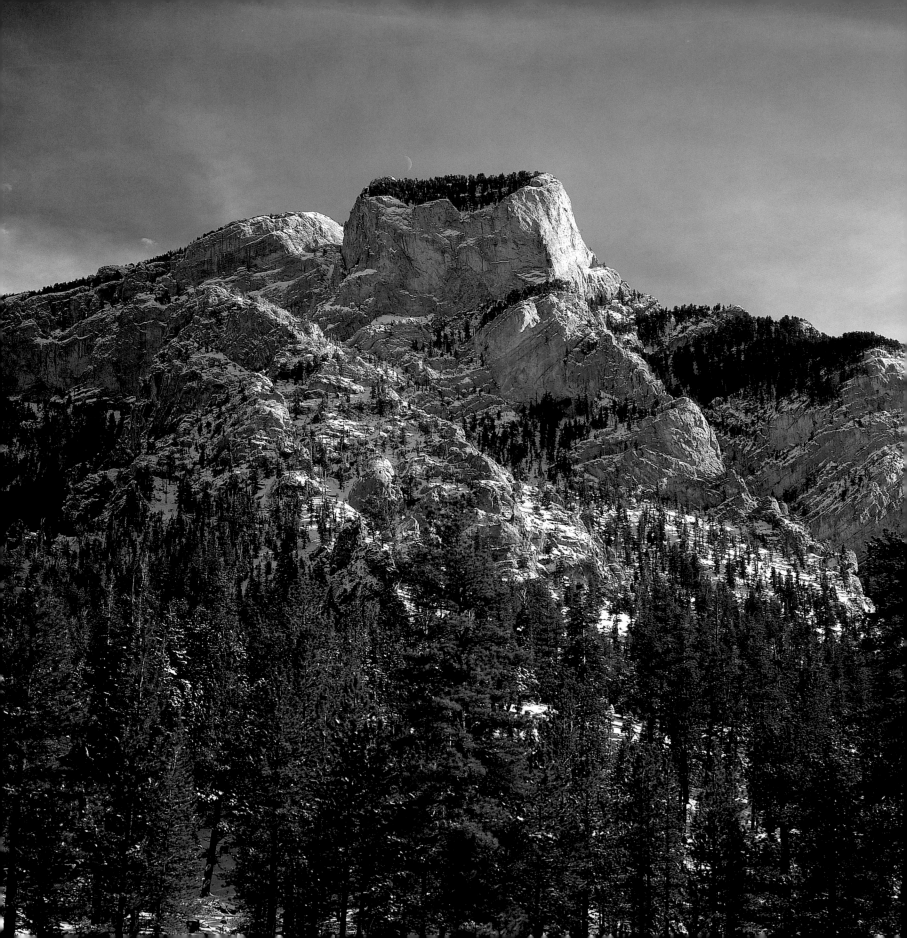

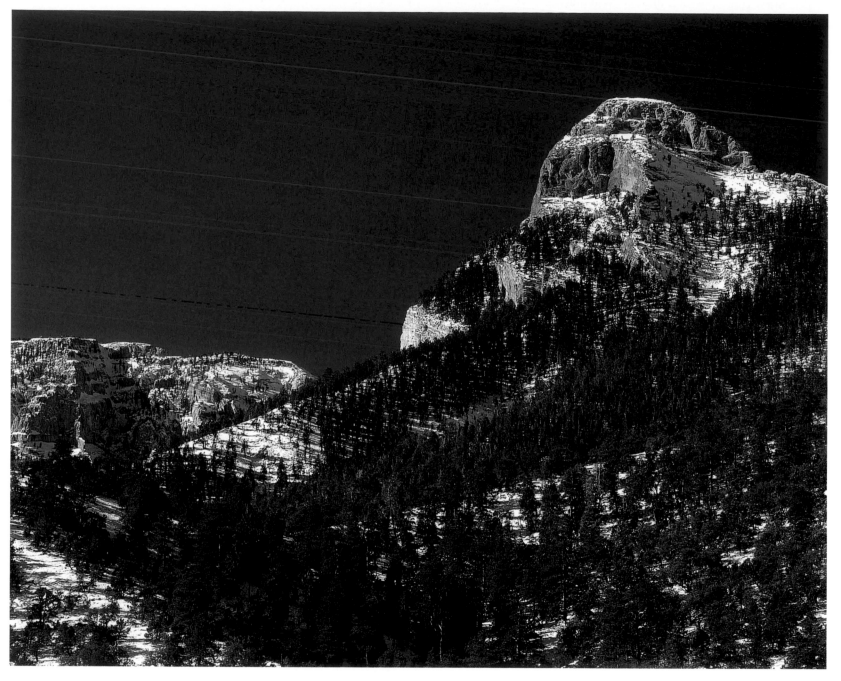

◄ On average, Mount Charleston
is 25 to 30 degrees cooler than Las Vegas in
summer, making it a favorite getaway from the city's heat.
▲ At 11,918 feet above sea level, Charleston Peak
is the eighth-highest peak in Nevada.

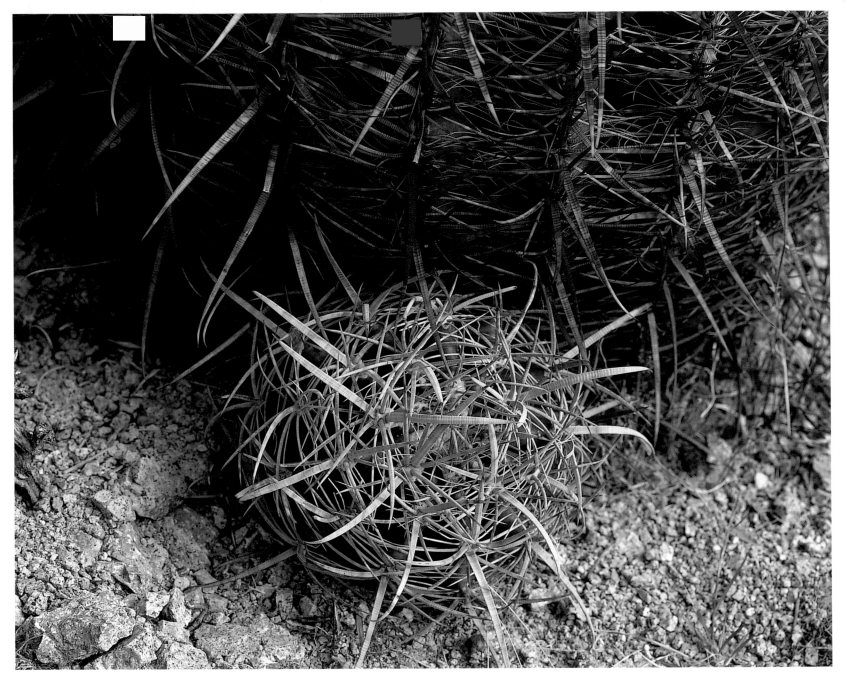

▲ The pleated shape of the barrel cactus allows it to expand when it rains and store water in its spongy tissue. It shrinks in size during dry times as it uses the stored water.

▶ Cholla cacti (genus *Opuntia*) dot the hills at Eagle Wash. *Opuntia* are unique because of their clusters of fine, tiny, barbed spines called glochids. Glochids are yellow or red, sometimes inviting a soft touch—but beware! They detach easily from the stems and are often difficult to see or to remove from the skin.

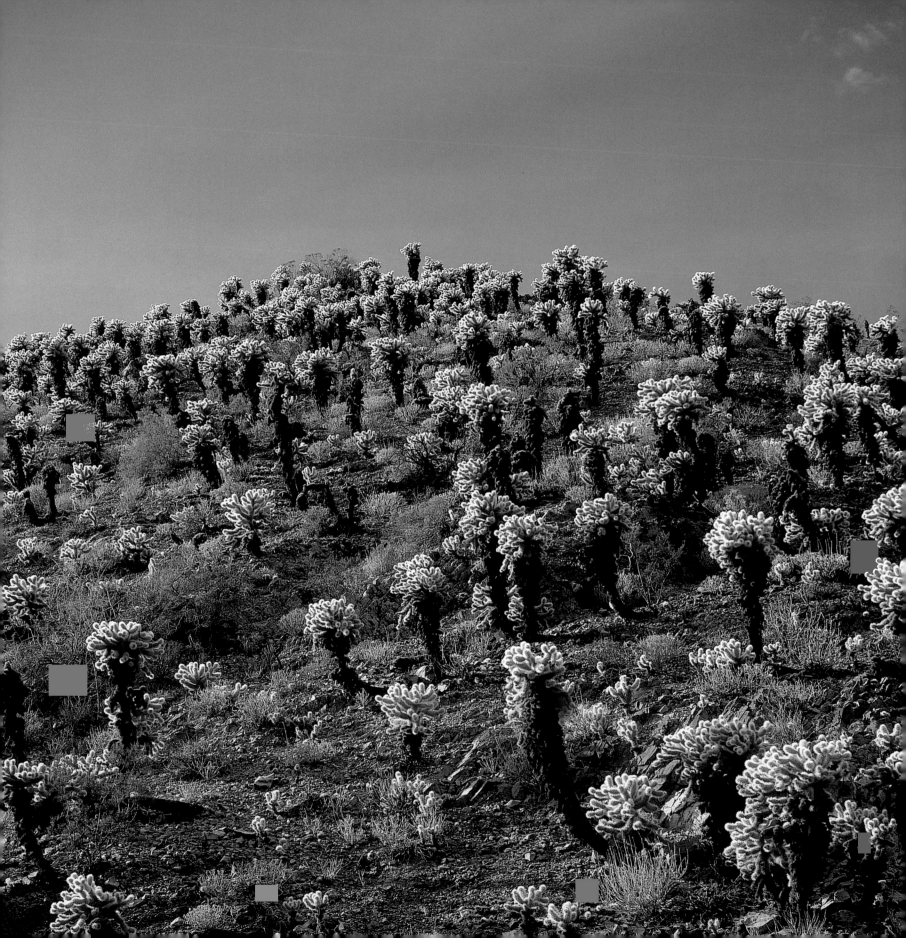

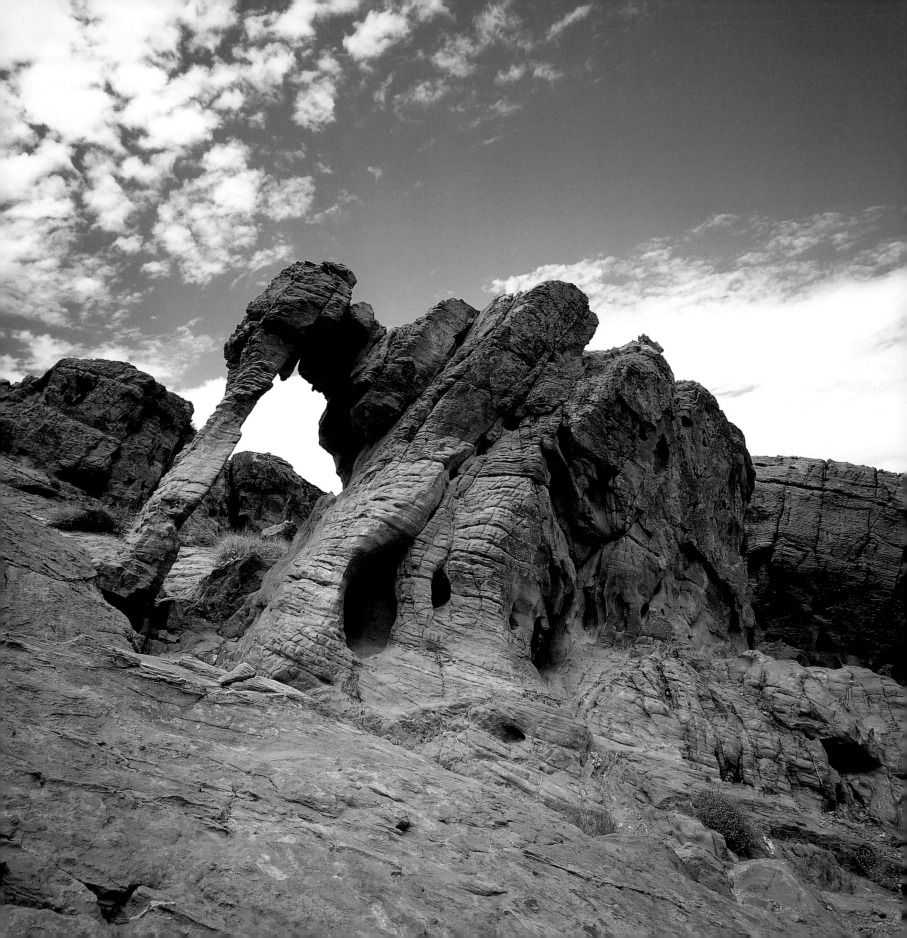

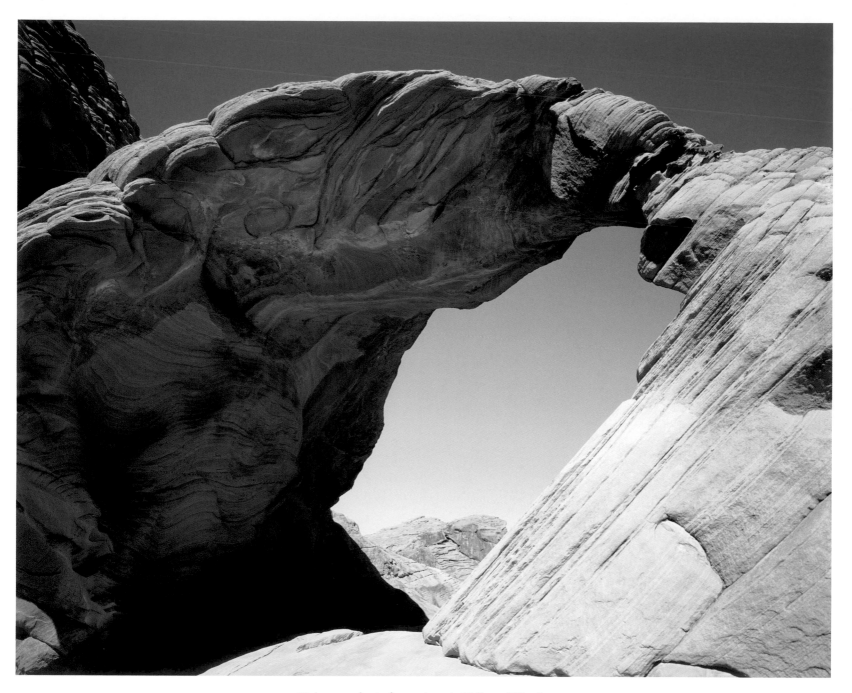

◄ Unique geologic formations in Valley of Fire State
Park include such fanciful shapes as the Beehives, Petrified
Logs, Mouse's Tank, Seven Sisters, and, as seen here, Elephant Rock.
▲ Arch Rock is ensconced in Valley of Fire. The valley derives its name from the
red sandstone formations and the stark beauty of the Mojave Desert.

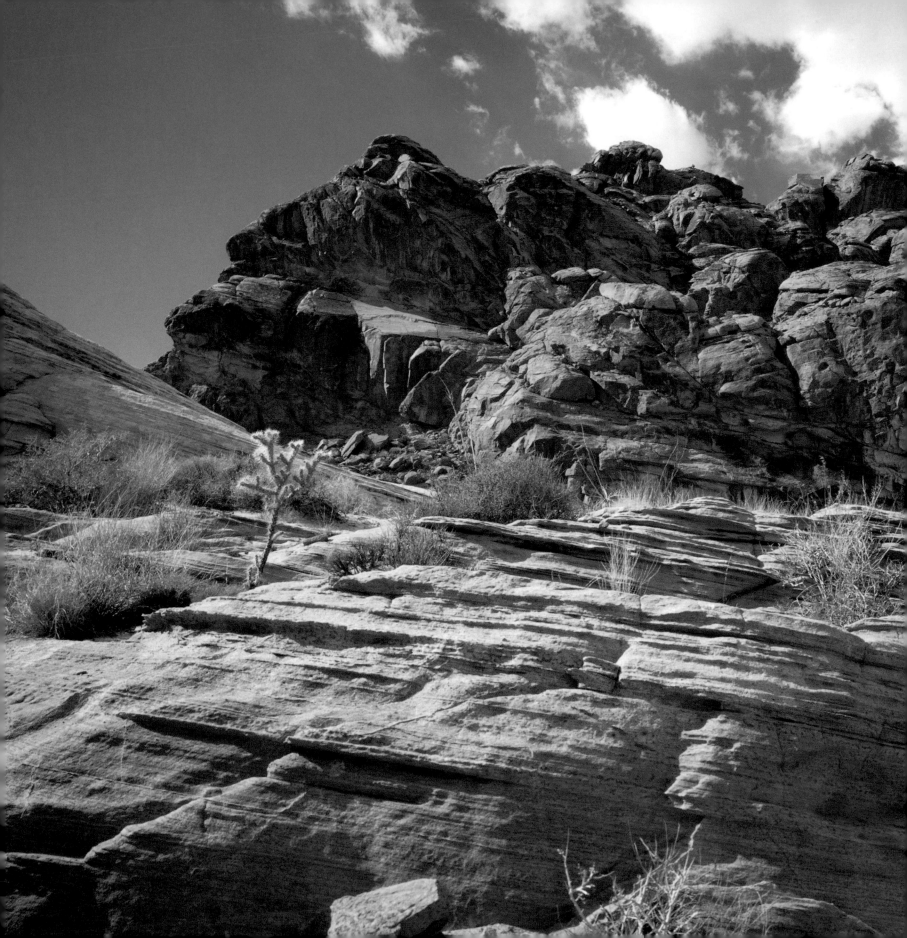

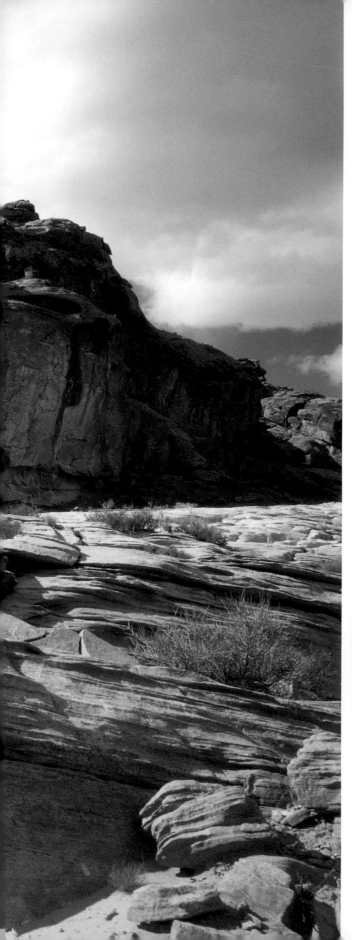

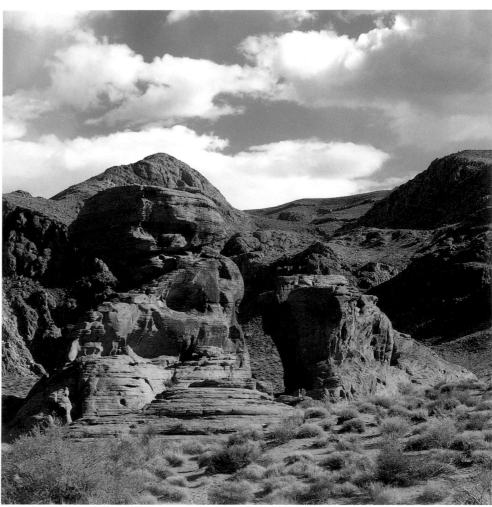

◄ White Domes is an unusual sandstone
formation. Situated in Valley of Fire State Park,
Nevada's oldest and largest state park, White Domes'
contrasting colors make it a popular hiking destination.
▲ Sandstone rock formations at a group campsite in Valley of
Fire State Park make for interesting terrain.

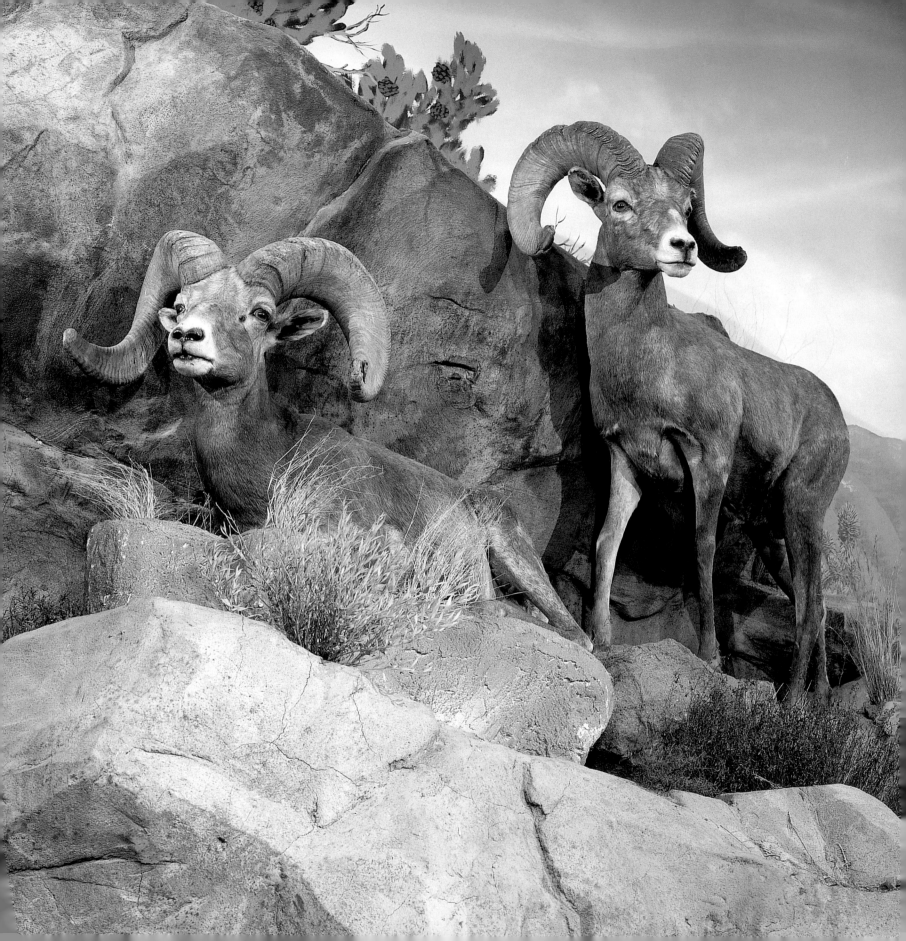

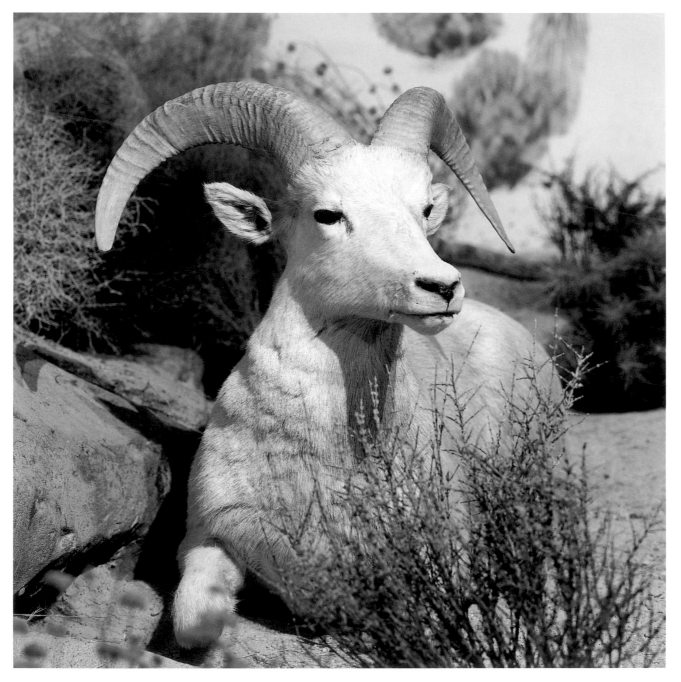

◄ One of the most majestic creatures of the
North American deserts, and one of the rarest, is the
desert bighorn sheep. Male horns can weigh as much as thirty pounds.
▲ Bighorn ewes, the females, are smaller than the rams and have
shorter, smaller horns that never exceed half a curl.

▲ The rocky shapes in Bitter Springs Valley, in the
Lake Mead National Recreation Area, are nearly obscured by rain.
▶ The water at Willow Spring, in Red Rock Canyon, attracts
a wide variety of wildlife, including rare birds, making
the area a popular destination for bird-watchers.

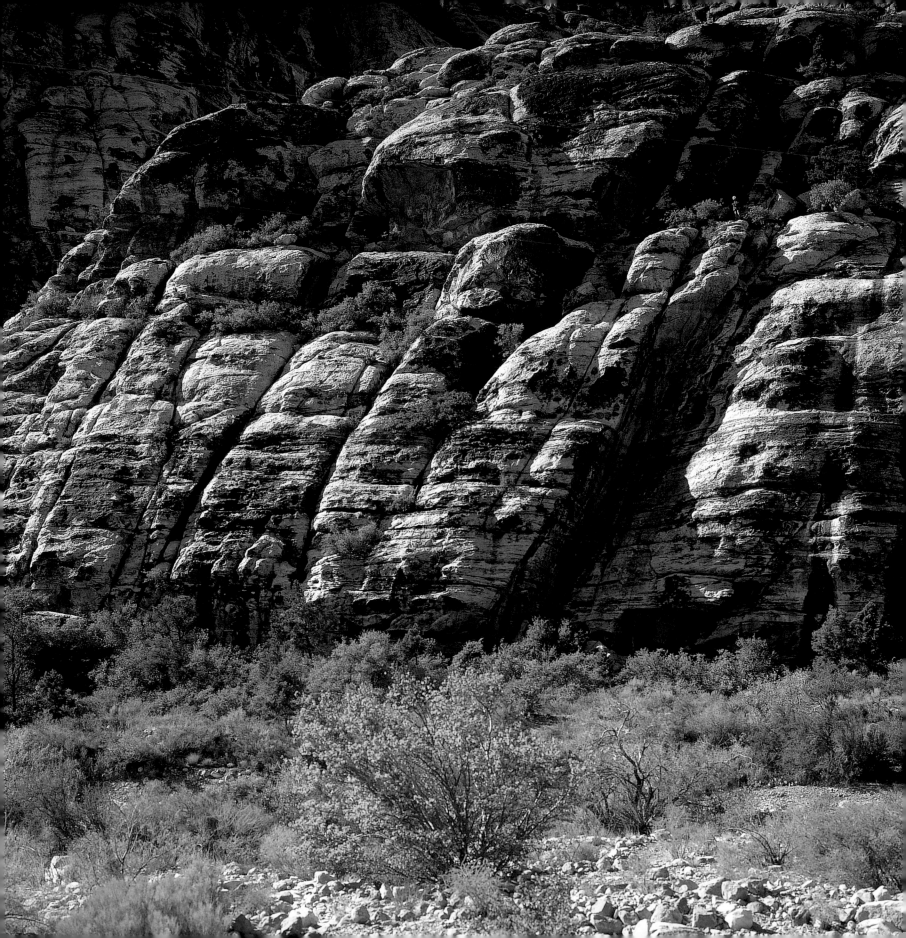

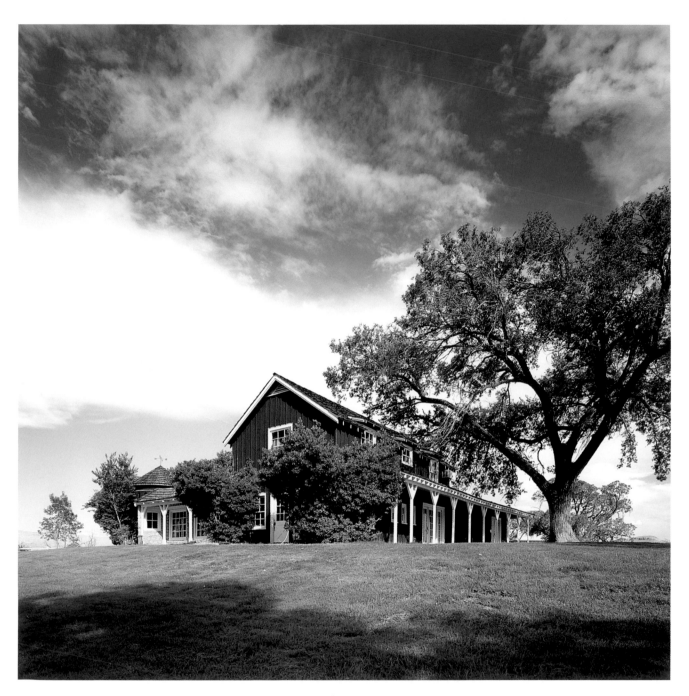

◄ Aztec sandstone comes in a
variety of colors: yellow, white, tans, and reds.
▲ The 520-acre Spring Mountain Ranch State Park, located
within the Red Rock Canyon National Conservation Area, nestles
beneath the colorful cliffs of the Wilson Range. Once a
working ranch, the state park now conducts guided
nature hikes and living history programs.

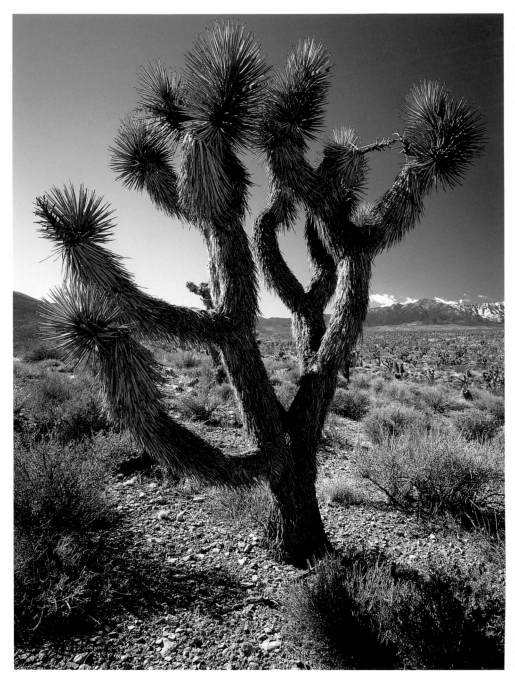

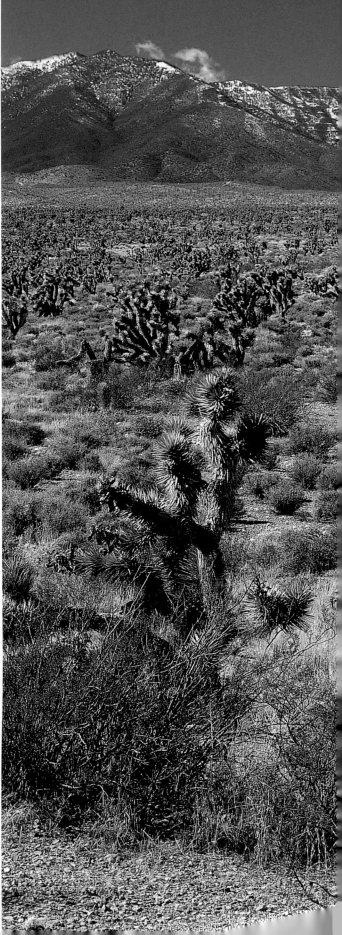

▲ A Joshua tree is silhouetted against
the sky in the Mount Charleston Wilderness Area.
▶ Joshua trees populate Kyle Canyon. The weirdly shaped trees
were so named by the Mormons because the branches,
or "arms," reach for the sky, suggestive of the biblical
Joshua lifting his arms heavenward in prayer.

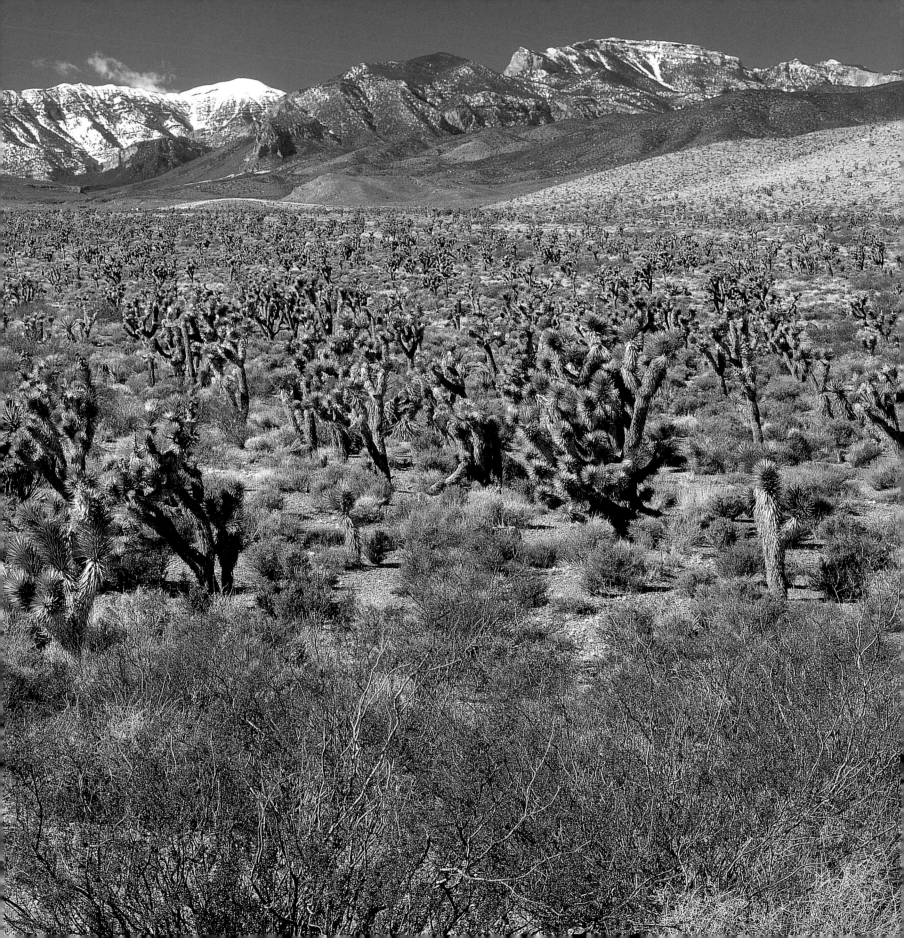

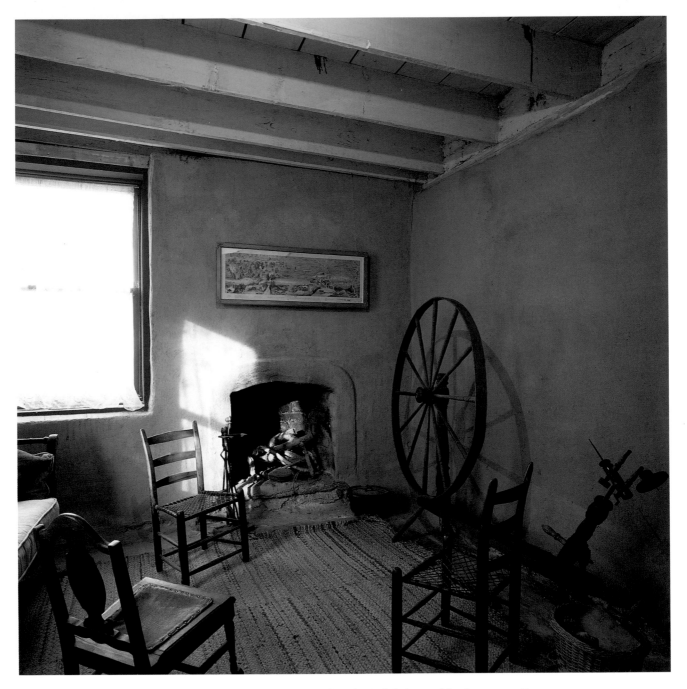

▲ Old Las Vegas Mormon State Historic Park is located in downtown Las Vegas. The first permanent non-Native settlers in Las Vegas Valley were Mormon missionaries who built an adobe fort along Las Vegas Creek in 1855. The park includes a remnant of the original fort, which serves as a visitor center with interpretive displays.

▶ Historic re-creation and interpretation are an ongoing focus of the historic park.

▶▶ "'Til we meet again" shines as part of the Fremont Street Light Show.

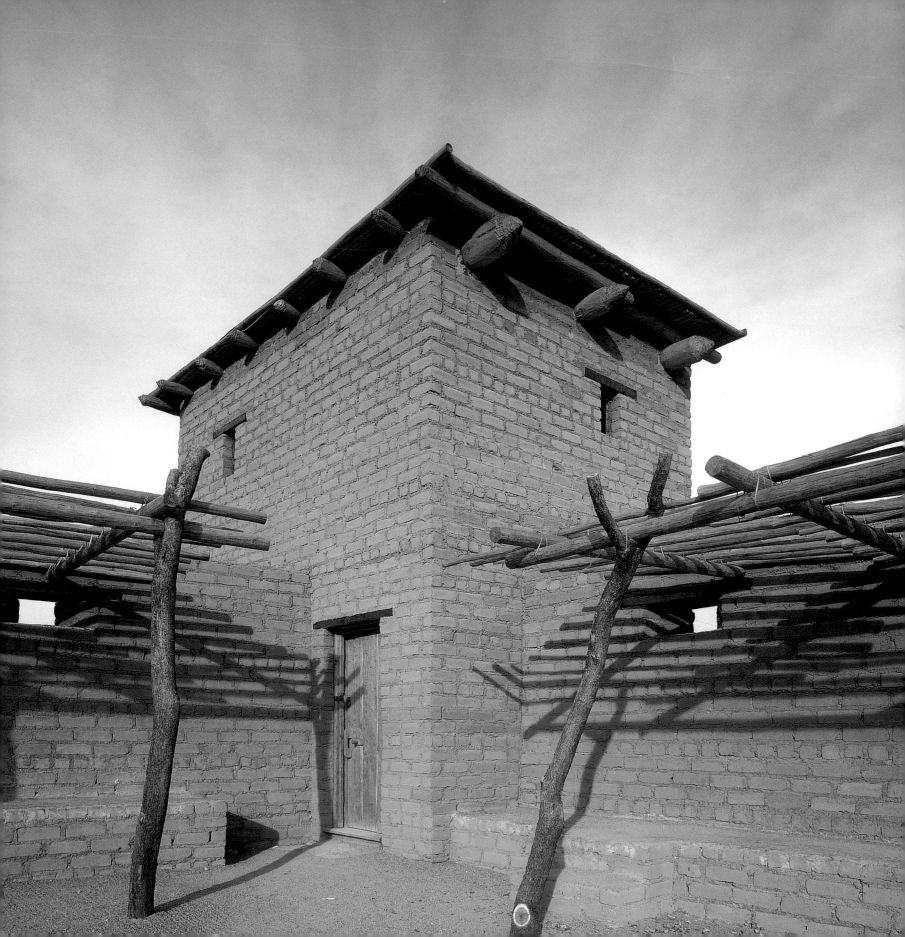

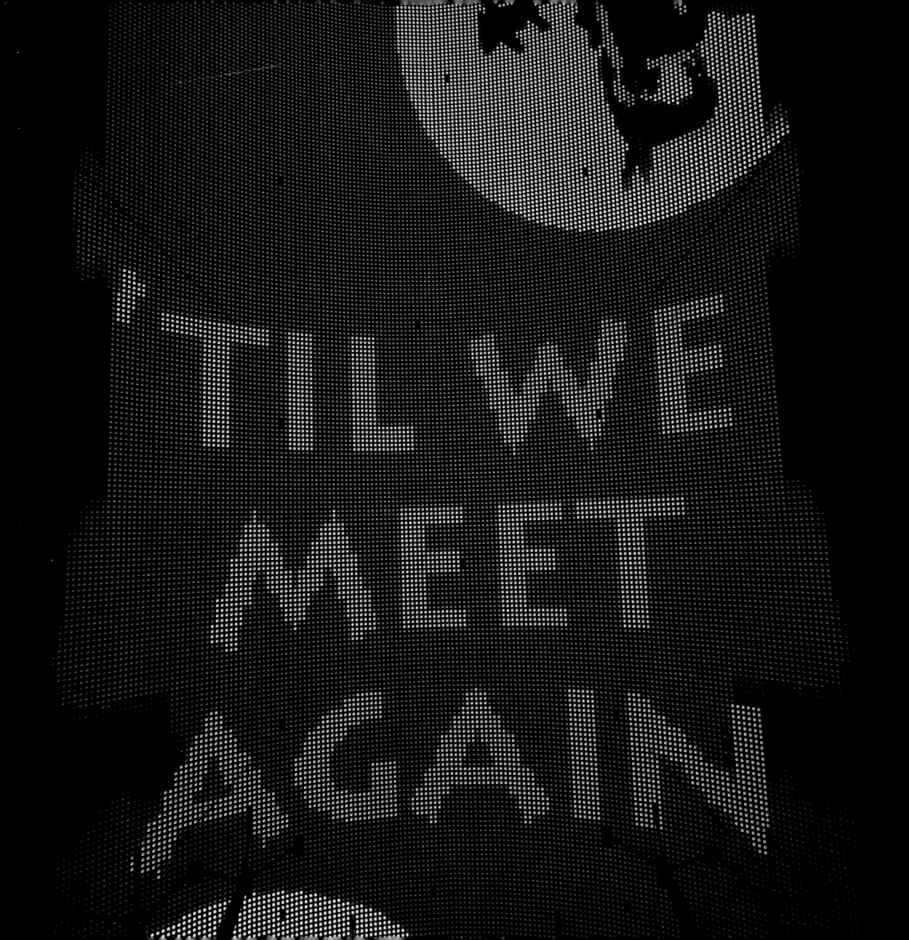